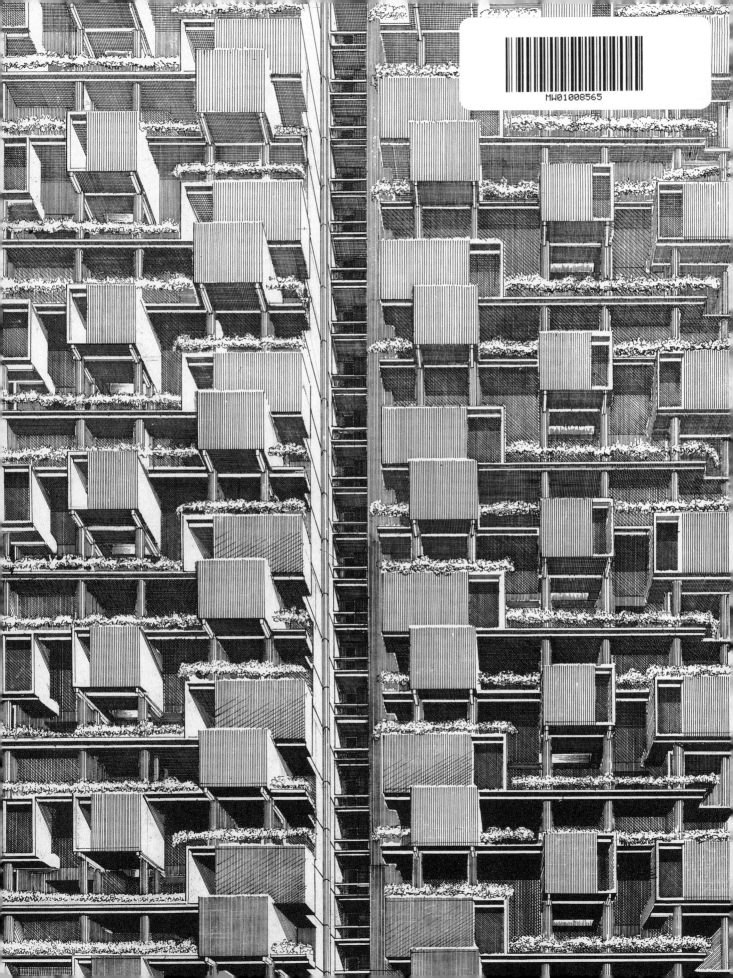

MATERIALIZED SPACE

THE ARCHITECTURE OF PAUL RUDOLPH

Abraham Thomas

The Metropolitan Museum of Art, New York
Distributed by Yale University Press, New Haven and London

DIRECTOR'S FOREWORD

Paul Rudolph was one of the most significant architects of the twentieth century, a second-generation modernist who rose to prominence during the 1950s and 1960s alongside peers such as Eero Saarinen and I. M. Pei. Although he was best known for his large projects constructed in concrete and his associations with the architectural movement known as Brutalism, his career was fascinatingly diverse. Rudolph's contributions to architecture include pioneering modernist houses of the 1940s and 1950s in Florida; the Brutalist civic buildings and urban megastructures of the 1960s that he became renowned for; spatially complex—and spectacular—New York townhouse interiors of the 1970s; and mixed-use commercial skyscrapers in Asia planned during the 1980s economic boom. While ranging widely in context and scale, these projects are unified by their experimentation with materials and nuanced exploration of architectural space.

Until now, there has never been a major exhibition on the work of Paul Rudolph, and it would not have been possible for The Met to stage such an ambitious project without the generous loans from the Paul Marvin Rudolph Archive at the Library of Congress. I would like to extend a special thanks to Dr. Carla Hayden, the Librarian of Congress, and her colleagues for their close collaboration on this exhibition, which has allowed us to share these stunning original drawings, models, and other items from Rudolph's architectural office with our visitors. We are equally grateful to the other institutional and private lenders whose loans have enhanced the richness and texture of the exhibition.

Materialized Space: The Architecture of Paul Rudolph is also The Met's first significant survey of a twentieth-century architect in more than fifty years, since our Marcel Breuer retrospective in 1972. This endeavor reflects the Museum's recent renewed commitment to showcasing modern and contemporary architecture and design as part of its collecting strategy and exhibition programming.

The curatorial vision and content for the exhibition and catalogue were expertly developed by Abraham Thomas, Daniel Brodsky Curator of Modern Architecture, Design, and Decorative Arts, who conducted extensive research in the Rudolph archives and has assembled here several works that have never been on view before, giving us new insights into Rudolph's career and working process. I would also like to thank David Breslin, Leonard A. Lauder Curator in Charge of the Department of Modern and Contemporary Art, for steering and supporting the exhibition, in addition to the many other colleagues, both within the Museum's walls and beyond, who contributed to making this project a reality.

I send my thanks to The Modern Circle for their support of this exhibition. My gratitude is also due to The Daniel and Estrellita Brodsky Foundation and Ann M. Spruill and Daniel H. Cantwell, whose investment in this exhibition is deeply appreciated. For supporting this exhibition catalogue we gratefully acknowledge the Samuel I. Newhouse Foundation, Inc.

Paul Rudolph's projects wrestled with many thorny issues of cultural, economic, and political significance during the middle part of the twentieth century—for example, postwar urban renewal, the need for public housing, and the struggle to shape better communities through architecture—all topics that seem just as urgent today, as we reexamine the legacy of this important and captivating architect.

Max Hollein
Marina Kellen French Director and CEO, The Metropolitan Museum of Art

ACKNOWLEDGMENTS

No exhibition at The Metropolitan Museum of Art can take place without the vital contributions of many individuals both inside and outside the Museum, as well as the generosity of private and institutional lenders and supporters. For their leadership and encouragement throughout all stages of this project's development, I would like to extend a special note of thanks to Max Hollein, the Museum's Marina Kellen French Director and CEO; Quincy Houghton, Deputy Director for Exhibitions and International Initiatives; David Breslin, Leonard A. Lauder Curator in Charge of the Department of Modern and Contemporary Art; and Sheena Wagstaff, the former Leonard A. Lauder Chair of the Department.

For their lead support of this exhibition, my deep appreciation goes to The Met's Modern Circle. Additional major gifts came from The Daniel and Estrellita Brodsky Foundation, and Ann M. Spruill and Daniel H. Cantwell. The accompanying publication is the result of generous support from the Samuel I. Newhouse Foundation, Inc.

Just before his death in 1997, Paul Rudolph bequeathed to the Library of Congress his architectural archive of more than 100,000 items, encompassing drawings, models, photographs, and printed ephemera. This exhibition, the first-ever major survey of Rudolph's career, would not have been possible without the extensive loans from the Library of Congress, including several objects that have never been on view before and in some cases have never even been photographed. Therefore, I am indebted, first and foremost, to my colleagues in the Library's Prints and Photographs Division, who during the past two years have been unfailingly generous and collaborative in making this unprecedented exhibition happen. I would like to extend special thanks to Mari Nakahara, Curator of Architecture, Design, and Engineering, who was an early partner on this project and was exceedingly helpful during my initial research visits to the archive, when the two of us viewed thousands of drawings for days at a time. Rachel Waldron, Senior Exhibits Registrar, was also essential in coordinating and facilitating these complicated loans. Other staff at the Library of Congress who contributed to this project include David S. Mandel, Helena Zinkham, Elizabeth Peirce, Kaare Chaffee, Sara Duke, and Maria G. Mizes Hickey.

Another key lender was the Paul Rudolph Institute for Modern Architecture, and I am grateful to Kelvin Dickinson and Ernst Wagner for allowing us to borrow important examples of furniture and other objects from the Paul Rudolph estate, hosting numerous visits to Rudolph's landmark Modulightor Building on East 58th Street, and engaging in conversations with me about his life, work, and collecting.

I would also like to thank Martino Stierli and Paul Galloway at the Museum of Modern Art and Rebecca Hatcher and Marie-France Lemay at Yale University's Beinecke Library for lending Rudolph drawings from their institutional collections, as well as Barbara Pine, Andrew Benner, Sean Khorsandi, and Dan Webre for their willingness to lend objects from their private collections.

I am appreciative of many colleagues across The Met for their sustained commitment, enthusiasm, patience, and good cheer during this journey into Rudolph's life and career. Colleagues in the Department of Modern and Contemporary Art who were instrumental to the success of this exhibition include Katy Uravitch, Tiarra Brown, Mallory Roark, Cynthia Iavarone, Brooks Shaver, Lionel Carre, Zachary Hewitt, Nalani Williams,

Michaela Bubier, and Pari Stave. They made this project a truly departmental team effort.

This complex exhibition consists almost entirely of external loans entailing a range of object types. For their dedication and diligence in carrying out the logistical work, I would like to especially thank Aileen Marcantonio and Marci King in the Exhibitions Office and Meryl Cohen, Becca Young, and Allison Barone in the Registrar's Office. For preparing the large number of incoming loans, I greatly appreciate the work of Rachel A. Mustalish, Sherman Fairchild Conservator in Charge of the Department of Paper Conservation, and Kendra Roth, Melissa David, and Frederick Sager in the Department of Objects Conservation. For the beautiful and compelling design of the exhibition, I am grateful to Lin Sen Chai and Sarah Pulvirenti, together with their colleagues Jourdan Ferguson, Hamilton Guillén, and Aichi Lee, in the Design Department, led by Alicia Cheng; as well as Maria Nicolino in the Buildings Department.

This beautiful catalogue would not exist if it were not for the superlative efforts, dedication, and care of our Publications and Editorial team, led by Mark Polizzotti, Michael Sittenfeld, and Peter Antony. My deepest gratitude goes to Elisa Urbanelli for her wonderful collaboration as the editor of this book and for her excellent suggestions and careful, patient consideration of the text as it evolved, making it much more engaging to read. Lauren Knighton handled the production of the book with aplomb and shepherded it to press with a passionate eye for detail. Jenn Sherman did a remarkable job researching, gathering, and securing the rights for the book's images. I am also thankful to Cecilia Wedell for her great work editing and shaping the exhibition's interpretative texts.

The carefully poised composition and arresting clarity of the book's design are owed to the efforts of Michael Dyer (a bona fide Rudolph fan!) of Remake. Many of the most striking photographs in this book appear courtesy of the photographer Ezra Stoller's decades-long collaboration with Paul Rudolph, and I am deeply grateful to Erica Stoller for allowing us to include so many of her father's important and memorable images of Rudolph's buildings.

In the Development Department, Whitney W. Donhauser, Stephen A. Manzi, Jason Herrick, Padget Sutherland, Evie Chabot, and Kimberly McCarthy are owed my sincere thanks. In The Thomas J. Watson Library, Kenneth Soehner, Arthur K. Watson Chief Librarian, and Tina Lidogoster were extremely helpful in securing examples of printed ephemera for the exhibition. Eileen Travell in the Imaging Department captured beautiful images of several Paul Rudolph objects and spaces. In the Digital Department, Kate Farrell, Melissa Bell, and Paul Caro worked tirelessly and creatively to help compile the film clips for the exhibition. We received invaluable advice from Cristina Del Valle and Emily Balter in the Counsel's Office. Kate Swanson and Grace Rago in the Education Department ably corralled programming ideas. I would also like to express my thanks to Alexandra Kozlakowski in the Communications Department for her dedication and creativity in overseeing the promotion and press coverage for the exhibition.

Finally, I would like to thank all of the external colleagues and Rudolph aficionados who took the time to speak to me at various points

during the exhibition's gestation and my research to share their knowledge of and enthusiasm for Paul Rudolph's contributions to architecture. Some knew him personally and worked with him, some helped steward his architectural archive, and some are scholars of his work. There are too many individuals to list exhaustively, but for their recollections and insights I am especially grateful to members of the Paul Rudolph Foundation (George Balle, Ian Gilchrist, Sean Khorsandi, and Dan Webre), Ford Peatross, Helen Bechtel, Timothy Rohan, Allan Greenberg, Robert A. M. Stern, Deborah Berke, Max Protech, Sid Bass, and Iwan Baan. Inevitably, the conversations will only multiply as we continue to unpack, analyze, and reassess the fascinating life and architectural career of Paul Rudolph.

Abraham Thomas
Daniel Brodsky Curator of Modern Architecture, Design, and Decorative Arts,
The Metropolitan Museum of Art

INTRODUCTION

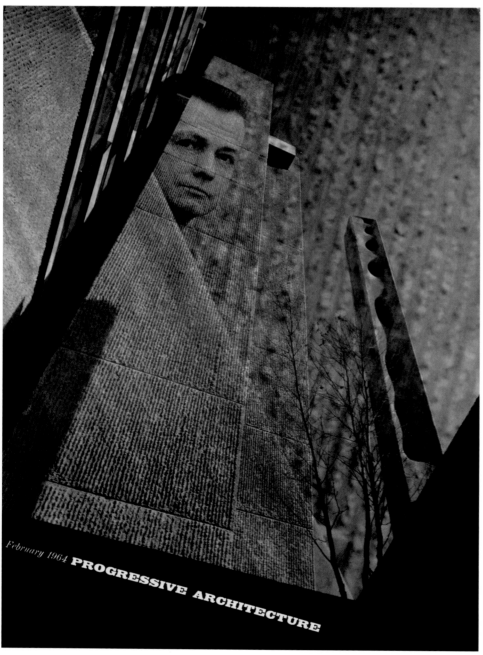

Fig.1 Cover of *Progressive Architecture*, February 1964,
featuring a portrait of Rudolph superimposed on
the Art and Architecture Building at Yale University,
New Haven, Connecticut

The *New York Times* obituary for Paul Rudolph (1918–1997) summed up his career as "a perplexing legacy that will take many years to untangle."[1] Indeed, in the almost three decades since his death, architects and historians have grappled with the life and work of this controversial figure who "epitomized the turbulence that engulfed American modernism in the 1960s."[2] Among the leading architects of his time, Rudolph stood shoulder to shoulder alongside other second-generation modernists such as Eero Saarinen, Louis Kahn, Philip Johnson, and I. M. Pei. In an intense period during the late 1950s and early 1960s, his projects graced the covers of seemingly every architectural magazine in the country (fig. 1). One could argue that he often eclipsed his peers, all of whom are arguably better known today, perhaps due to the extent of their surviving built legacy when compared to Rudolph's. However, as the 1960s came to a close, Rudolph suddenly experienced a precipitous decline in reputation, virtually disappearing and retreating from the mainstream architectural world for a decade. Refocusing his energies, he pivoted toward highly experimental interior projects before reemerging on the international architectural stage during the 1980s and 1990s with large-scale commercial projects in East Asia, many of which were active when he died.

It can be challenging to categorize Rudolph's output holistically, as his projects range dramatically in scale and span a diverse array of programmatic functions and contexts. And yet, fascinating commonalities—for example, a focus on innovative materials and modular construction methods—are discernible across his body of work. From his early experimental houses in Florida, to his Brutalist civic commissions rendered in concrete, and from his utopian visions for urban megastructures and mixed-use skyscrapers to his extraordinary immersive New York interiors—collectively, his projects offer us an intriguing, if confounding and self-contradictory, set of propositions to consider. The paradoxical nature of his work was apparent even at the height of his career, when a 1967 *New York Times Magazine* cover story (see fig. 16) posited Rudolph as a natural successor to Le Corbusier, suggesting that his emphasis on intuition was the driving force behind an architectural unpredictability that could "turn out to be anything: a staggered complex of cubes or a soaring, sweeping affair, plain or fancy, lovely or lousy."[3] As a result of these perceived inconsistencies, his career has often been dismissed as an inconvenient blip within the grand arc of late modernism, depicted as too quirky and too slippery to grasp. This characterization perhaps explains why—despite the critical acclaim and extensive coverage that he received during his boom years—there was a relative dearth of significant literature on Rudolph until scholars in the past decade or so started to reexamine and unpack his legacy.[4]

Unlike peers such as Saarinen and Kahn, Rudolph, until now, has never been the subject of a major exhibition that spans the full breadth of his output and takes full advantage of the original design material from his archives. In recent years, a spate of demolitions of key projects has renewed focus on Rudolph, not only drawing attention to his lost built work but also sparking debate around the preservation of late twentieth-century architecture, particularly the contentious buildings associated with Brutalism and exposed concrete construction.

Born in Elkton, Kentucky, in 1918, Rudolph graduated from Alabama Polytechnic Institute (now Auburn University) in 1940 with a degree in architecture. He went on to study under the influential Bauhaus cofounder Walter Gropius at the Harvard Graduate School of Design, where he was considered the foremost talent among his fellow students, including Johnson, Pei, and Edward Larrabee Barnes.[5] Following the United States' entry into World War II he served at the Brooklyn Navy Yard, where he supervised ship repair and witnessed firsthand the advantages of lightweight construction techniques and innovative materials. After the war ended, Rudolph returned to Harvard to complete his postgraduate studies.

In the late 1940s Rudolph established a base on the Gulf Coast of Florida where, in partnership with the architect Ralph Twitchell, he developed the so-called Sarasota Modern style and gained national fame with a series of small-scale, functionalist houses that experimented with modern materials such as plywood and plastics. He started his own practice in 1952 and began acquiring a formidable reputation as a rising star within the architectural firmament. He was asked to return to military service at the start of the Korean War but received a defer-

ment, thanks in part to an impassioned letter submitted to the Department of the Navy by Gropius, who declared "Lt. Rudolph" to be "one of the outstanding brilliant American architects of the younger generation ... well on the way to becoming internationally known for [his] strong and independent approach."[6] Unimpeded, Rudolph continued working, secured coveted teaching roles at some of the nation's leading architectural schools, and carefully cultivated the publication of his work in several key architectural journals. These efforts culminated in his appointment, in 1958, as chairman of the Department of Architecture at Yale University—all before he was forty, and a mere eleven years after his graduation from Harvard. Swiftly followed by the commission to design Yale's new Art and Architecture Building—probably considered his masterwork—his rapid ascent consolidated the perception of Rudolph as a "young mover, changing the look of American architecture" (fig. 2).

Rudolph's teaching philosophy advocated for an alternative to the prevalent International Style practiced by Gropius, Mies van der Rohe, and other modernists who favored lightweight structures, open plans, flat surfaces, and abundant glass planes. In contrast, Rudolph promoted a "New Monumentality," which the architectural historian and theorist Sigfried Giedion—an influence on Rudolph during the 1940s—characterized as a greater sculptural presence, architectonic expressiveness, and a richer visual variety.[7] When observing the seemingly repetitive facades of functionalist modern architecture, Rudolph articulated the dire need for more "caves" not just "gold-fish bowls,"[8] once stating, "surely mankind has never built such dry, timid, monotonous structures as we do today."[9] He even described the experience of driving down Park Avenue—with its rows of steel-and-glass skyscrapers—as "flipping through the pages of a window manufacturer's catalogue."[10] A search for texture and bold forms shaped many projects during Rudolph's peak career years of the 1960s, from urban civic buildings to new educational campuses and corporate office headquarters. It informed how he manipulated concrete surfaces and architectural massing by sculpting light and shadow, an approach dramatically demonstrated by the Yale Art and Architecture Building (see figs. 19–21). However, Rudolph also welcomed a broad

church at Yale, and during his seven-year tenure as chairman he transformed the department into one of the most exciting architectural programs in the country, with a glittering roster of visiting critics and teachers (many whose views diverged from Rudolph's) such as Alison and Peter Smithson, Serge Chermayeff, and James Stirling. His curriculum nurtured a succession of notable students and future architectural luminaries, including Norman Foster, Richard Rogers, Charles Gwathmey, Stanley Tigerman, and Robert A. M. Stern (fig. 3). Tigerman once offered an insight into both Rudolph's teaching approach and his stubbornly individualistic attitude: "He would brutalize people. Paul was a miserable, mean bastard [but also] simply the best teacher I ever had by far.... He walked the talk better than anybody I have ever known.... He was fabulous, he was a killer. Yale, but Paul Rudolph, specifically, invented me out of whole cloth. He fabricated me."[11]

Rudolph's departure from Yale in 1965 coincided with a shifting tide of architectural discourse and a seething atmosphere of political dissent and activism, both on campus and in society more broadly, whether protesting the Vietnam War or demanding civil rights. His brand of "heroic"[12] Brutalism seemed increasingly out of sync with the emerging self-critiques of postmodernism and the countercultural attitudes of the era. Rudolph left his academic role to dedicate himself fully to establishing a large architectural office in New York—to at last become a "skyscraper architect"[13]—hoping to capitalize on the momentum he had gained from the high-profile and widely published commissions of the previous few years. However, he found that both the funding landscape and public opinion were rapidly changing. With the prolonged military operation in Southeast Asia and a looming oil crisis, opportunities for the type of large-scale urban projects that had been abundant during the Kennedy and Johnson administrations simply dried up. Although he initially received a flurry of new commissions, many of his most ambitious schemes remained unbuilt.

Meanwhile, just a few years after its splashy opening, the Yale Art and Architecture Building, having sustained poor maintenance and deteriorating conditions, fell into a state of disrepair. Its misfortunes reflected Rudolph's professional challenges and seemed almost

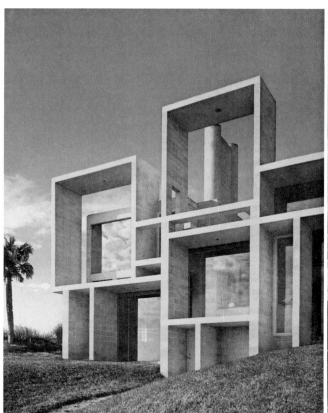
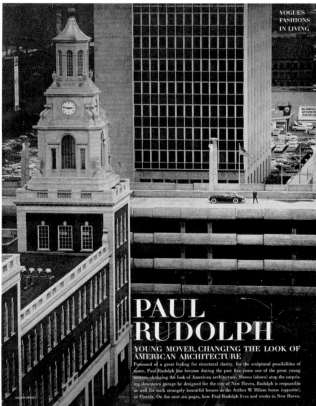
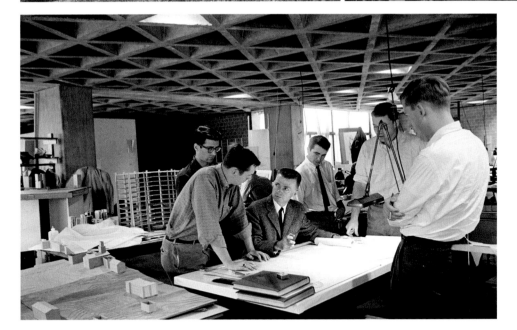

Fig. 2 Spread from "Paul Rudolph: Young Mover, Changing the Look of American Architecture," *Vogue*, January 15, 1963: (left) the Milam House in Jacksonville, Florida; (right) Rudolph with his 1950s Jaguar XK120 coupe on the roof of the Temple Street Parking Garage in New Haven, Connecticut. Photographs by Elliott Erwitt

Fig. 3 Rudolph with his students at Yale, before the opening of the Art and Architecture Building, ca. 1962. Photograph by Elliott Erwitt for *Vogue*

Fig. 4 Rudolph working on a drawing copy for the
Hiss House (Umbrella House) in 1955. Photograph
by Hans Namuth

emblematic of the developing frustrations with the architecture establishment. As a final insult, a fire that gutted major parts of the building in June 1969 was suspected at the time to be an act of arson initiated by students.

His large commissions floundering, Rudolph focused on spectacular interior projects that became his new platform for experimentation and visionary propositions. After a decade or so of relative invisibility within the architectural world—when his residential projects were published in interior-design magazines rather than architectural journals, and he was gaining notoriety for the perceived failures and delays of several "what-if" and "if-only" infrastructure and residential projects—Rudolph finally returned to the fray in the 1980s and 1990s with various large-scale projects in Hong Kong, Singapore, and Jakarta. At last, his chance to become a "skyscraper architect" had arrived, and with it came an opportunity to implement (albeit in slightly muted form) many of his ideas about modular design and the potential of the megastructure—a building or complex of related buildings assembled from clusters of interlocking forms—that had been gestating during the previous few decades. Rudolph appeared to thrive in a different cultural, financial, and climactic context and was clearly just as busy as ever, working to the very end in a whirl of productivity, with several projects still in progress when he died in 1997. His late ventures in Asia offered a chance for many in the architectural field to refamiliarize themselves with his previous projects, kickstarting a process of reassessment that continues to this day.

Given that a number of his buildings have been destroyed and some of his most well-known projects remain unbuilt, Rudolph's work has become defined by the legacy of his drawings, in particular the large-scale, richly delineated renderings for which he became famous. Considered by his peers and future generations of designers as a supremely talented draftsman, Rudolph was quite rare for being a "name on the door" lead architect who also authored the office's presentation drawings (fig. 4). These perspective views, elevations, and sections often acted as more effective advocates for his architectural vision than the finished buildings, and many of them are still regularly deployed as teaching tools in architectural schools today

(fig. 5). Norman Foster once recalled, "Paul Rudolph was the main reason that I chose to go to Yale University for the Masters course in architecture.... His drawings held a particular fascination for me—unlike those of other architects they were not only graphically seductive but also rigorous in the manner in which they revealed the anatomy and spatial qualities of his buildings."[14]

Interestingly, there is a direct relationship between Rudolph's drawing process and the construction choices he made. He explained, "Some construction materials are easier to depict through rendering than are others. This probably accounts for some of my interest in concrete and highly textured surfaces in general.... Rendering with line to create light and shadow suggests a certain linearity in the texture of walls, [influencing] the choice of materials." Acknowledging that some of his buildings could almost be considered physical manifestations of drawing techniques, he recalled that his initial use of "textured concrete ... started simultaneously with [a] concept of the rendering and how to make the buildings conform more exactly to the image as depicted."[15] This is particularly noticeable in the Yale building, which attracted criticism for the possibility that its compositional failings resulted from an overreliance on Rudolph's now-famous perspective section drawing of the project.[16] Referring to its textural qualities, the critic Reyner Banham observed, "It is one of the very few buildings I know which, when photographed, was exactly like a drawing, with all the shading on the outside coming out as if it were ruled in with a very soft pencil."[17]

Rudolph's drawings, as much as his executed projects, are a manifestation of materialized space. They express on the page a highly individualistic vision of the built environment that was only ever partially realized, despite boldly expressing itself through an extraordinary range of projects that spanned nimble private dwellings to urban-scale social-housing proposals. Whether exploring new materials and construction technologies, devising a new language of monumentality for civic buildings, or experimenting with immersive interiors and furniture design, Rudolph created a fascinating body of work that resonates with the undulating path of architectural discourse in the latter half of the twentieth century and leaves a legacy that remains ripe for investigation and further study.

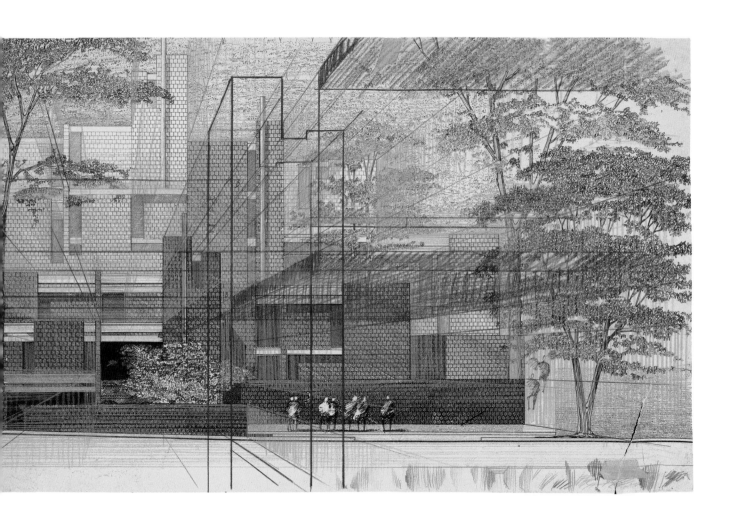

Fig. 5 Elevation drawing for Married Student Housing
at Yale University, New Haven, Connecticut,
ca. 1960

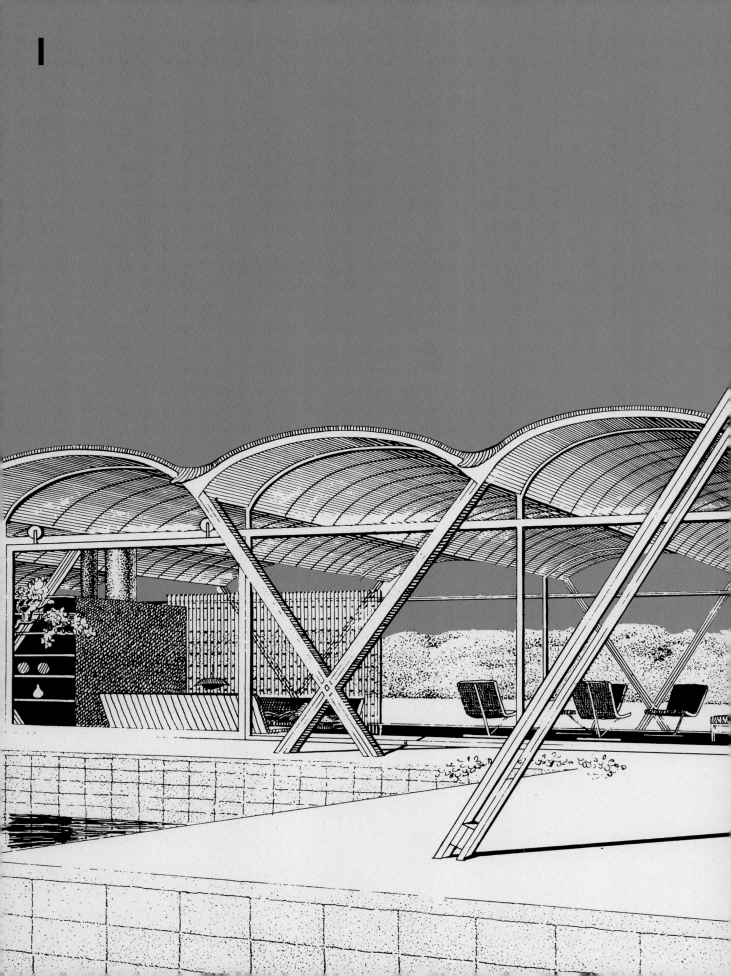

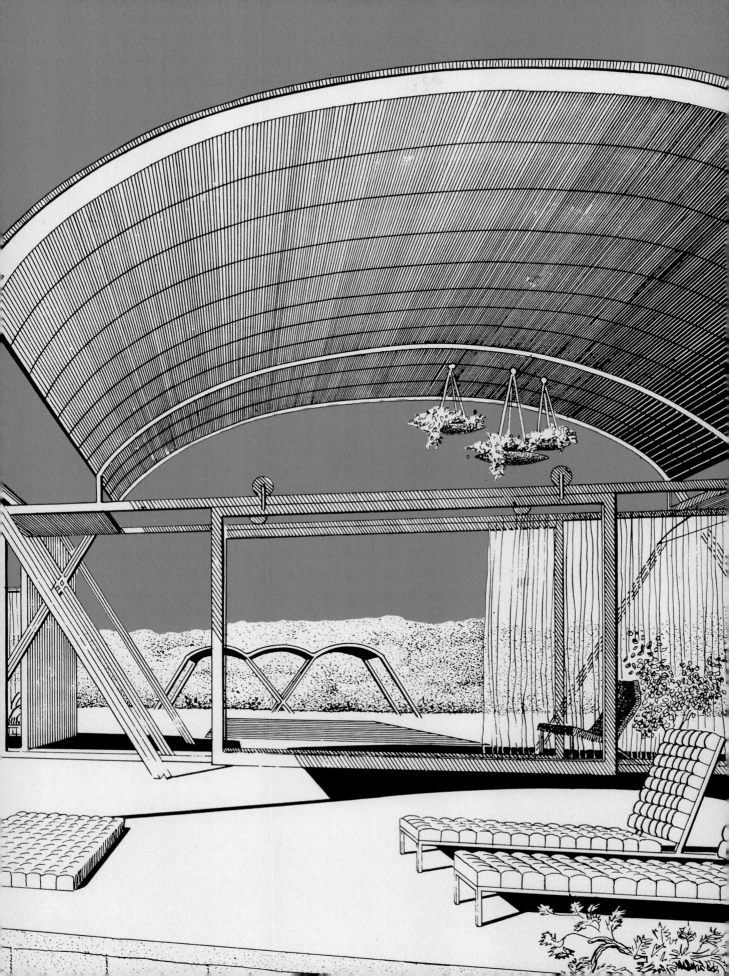

MODERN HOUSES

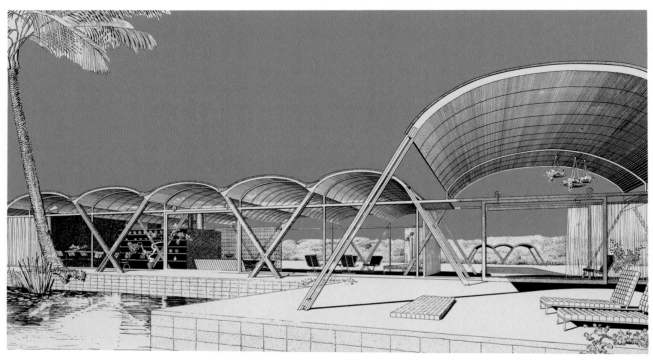

Fig. 6 Rendering of the Knott Residence (unbuilt),
 Yankeetown, Florida, ca. 1951

Throughout the ebbs and flows of his career, Paul Rudolph was deeply engaged with residential projects, whether small single-home commissions or large-scale public-housing schemes, which in many ways can be seen as a microcosm of the broader concerns and interests, as well as the challenges and opportunities, that preoccupied him. From his Sarasota Modern houses of the mid-1940s and 1950s, to the urban-renewal megastructure housing proposals of the late 1960s at his career peak, to the sprawling private residence in Singapore that he was working on at the time of his death in 1997[18]—these designs allowed Rudolph to explore experimental ideas about scale, form, materiality, and technology while also raising critical issues around the role of architecture within a community and its responsibility to society at large.

Rudolph's wartime service repairing ships for the Navy, along with his training at Harvard under Walter Gropius, guided the young architect's approach to applying industrial materials and efficient systems of construction. The inaugural issue of Yale's architectural journal *Perspecta*, published in the summer of 1952, showcased Rudolph, Philip Johnson, and Buckminster Fuller as three future "masters" of the architectural field who were taking the baton from Frank Lloyd Wright, Mies van der Rohe, and Le Corbusier. Here—in one of the earliest and most impactful articles about his work—Rudolph recounted his valuable experiences at the Brooklyn Navy Yard, where he witnessed the benefits of efficient, lightweight construction and came to appreciate how "the necessity of eliminating every possible pound sometimes produced elegant effects," predicting that "space-saving devices such as bulkheads constructed of steel or aluminum plates … will undoubtedly find their counterpart in paper-thin partitions yet to come."[19] He also credited Konrad Wachsmann, the German architect famous for his pioneering space-frame structures (geometric truss-like forms) and prefabricated modular building systems, for inspiration: "[Wachsmann] stimulated my own thinking in terms of the industrialization of structure and mechanical equipment [and] has carried further than anyone else the geometry and techniques which will eventually replace our largely craftsmanship methods of building today."[20] The two men likely met at Harvard while Wachsmann

was collaborating with Gropius on a "Packaged House System."

During the war Rudolph would have been familiar with plywood's various military uses, for which it was reserved exclusively and received huge government investment. The material's applications ranged from temporary housing and aircraft hangars to gliders and lifeboats. In 1944, while stationed in New York, Rudolph visited the *Design for Use* exhibition at the Museum of Modern Art, where he likely saw the large plywood parts fabricated for aircrafts by Charles and Ray Eames.[21] It is also possible that Rudolph was familiar with earlier experiments using the material, for example, Marcel Breuer's pioneering plywood designs, which were overseen by Gropius as controller of design at the Isokon Furniture Company in London during the mid-1930s. During the brief interlude between fleeing Nazi Germany and arriving at Harvard's Graduate School of Design, Gropius and Breuer were part of an avant-garde "Bauhaus in London" émigré community, which included László Moholy-Nagy, who would immigrate to Chicago.

In his experimental house projects of the early 1950s, Rudolph used thin sheets of bent plywood to create delicate arches—as either single vaults or modular units in sequence—whose economy of form allowed for maximum flexibility in the partitioning of internal spaces (fig. 6). According to Rudolph, these projects were the earliest examples of plywood applied to vaulting an architectural roof span, and he admitted that "the engineering involved was accomplished by trial and error, utilizing a few small boys jumping on various thicknesses of bent plywood in my backyard."[22] His time in the Navy proved to be "an internship in industrial construction at a vast scale, an opportunity [impossible] in the civilian world."[23] He not only observed innovative building systems but also gained knowledge of new industrial materials—in particular, plastics—that could be applied to architectural contexts. The Navy's "Operation Mothball," a program to weatherproof ships that were no longer in service, temporarily "cocooned" the structures by entirely wrapping them with a spray-on vinyl mixture that could stretch over gaps up to four inches wide.[24] The sealant had the unique ability to extend to "three times its original length, still returning to

its normal state,"[25] which to him represented a solution for waterproofing roof structures that were not entirely rigid, such as those composed of bent sheet materials that were "more eloquent than when used flat."[26] Rudolph applied this new military-funded spray-vinyl plastic to a few of his early Florida houses—creating watertight, yet flexible, roof structures—but nowhere was his exposure to naval technology more clearly manifested than in the Healy Guest House, also known as the Cocoon House (1948–50, figs. 7–9). Years later, when describing the origin of the project, Rudolph recalled, "It had to do purely with the idea of using the least material possible … and the whole notion of it being structurally clear. I was profoundly affected by ships.… I remember thinking that a destroyer was one of the most beautiful things in the world.… [And] the cocoon … was fascinating to me because of its elasticity."[27]

The Cocoon House was also an interesting statement on the notion of architectural transparency, a concept that was being explored at the same time in the bold modernist statements of Mies's Edith Farnsworth House (1945–51) and Johnson's Glass House (1947–49). However, rather than reduce the structure to a bare minimum of rigid steel I-beams and fixed plate glass, as Mies and Johnson had done, Rudolph introduced the warm texture of adjustable wooden louvers that extend across the long sides of the Cocoon House, creating a play of light and shadow, void and solid, open and closed. Although louvers were commonly used in the humid climate around Sarasota, providing a simple, yet flexible, shading and ventilation system, they very rarely took up entire walls. By angling the louvers according to the occupant's wishes, the house can either feel entirely enclosed and sheltered or be exposed to the elements, allowing the breeze to pass through freely. Jutting out on the bulkhead, with its projecting floor beams and flared roof, the Cocoon House resembles a large skiff boat about to launch, "poised at the water's edge with breathing walls and a spirit of light-heartedness," according to the architect.[28]

Rudolph and Twitchell often received multiple commissions from the same client, usually starting with an invitation to build the main residence and then following a year or two later with a request for a guest house, located

somewhere close by or on the same property. These smaller commissions usually had smaller budgets and therefore required the kind of imaginative thinking and efficient practices in which Rudolph had become well versed. Crucially, these satellite projects offered the young, ambitious architect the ideal test sites for experimentation with materials, space planning, and new technologies and construction methods. The Healy Guest House was one such example, and another was the Walker Guest House (1952, fig. 10), which was Rudolph's first project as a solo architect after he and Twitchell had worked together on the main Walker residence the previous year. The client, Dr. Walter Walker (grandson of the founder of the Walker Art Center in Minneapolis), invited Rudolph to design a small house that his family could live in while construction continued on the larger house.

For Rudolph, this project was a culmination of various experiments and new design approaches that had been simmering during the early years of his career and represents the high point of his work in Florida. Widely acclaimed at the time, it was later named one of the most important houses of the twentieth century in a 1957 survey of *Architectural Record*'s readers, along with the Farnsworth House and Glass House.[29] The Walker Guest House is essentially an efficient, lightweight pavilion, constructed using white-painted wood, steel, and glass, and arranged around the concept of a simple, square volume. An external wooden framework on all four sides not only extends the geometry of the structure to define a surrounding outdoor space but also supports an ingenious rigging system of pulleys and cannonball counterweights (delightfully painted a vivid red) that manipulate twelve giant plywood shutters, three on each side. Although requiring some hefty upper body strength, these "flaps" can either be lowered for privacy or protection from severe weather, or raised to allow daylight and gentle breezes into the interior, while simultaneously providing shade for the external veranda condition. With its precisely engineered symmetry and geometric white frame, the structure resembles an abstract classical temple while also suggesting the vernacular architecture of screened porches in the South.[30] Rudolph once evocatively described how it "crouches like a

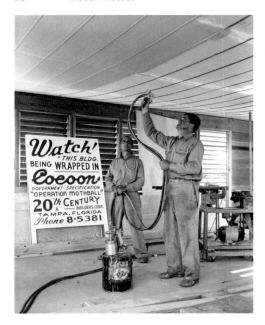

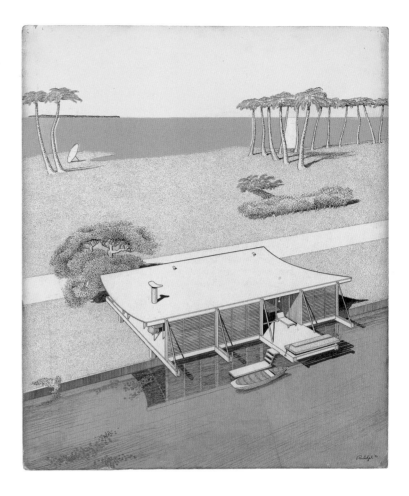

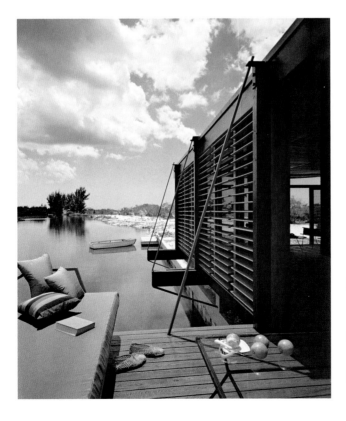

Fig. 7 Workers spraying "Cocoon" plastic material on
 the ceiling during construction of the Healy
 Guest House (Cocoon House), Sarasota, Florida.
 Photograph by Joseph Janney Steinmetz
Fig. 8 Aerial perspective drawing of the Healy Guest
 House (Cocoon House), Sarasota, Florida,
 1948–50
Fig. 9 Healy Guest House (Cocoon House), Sarasota,
 Florida, 1948–50. Photograph by Ezra Stoller

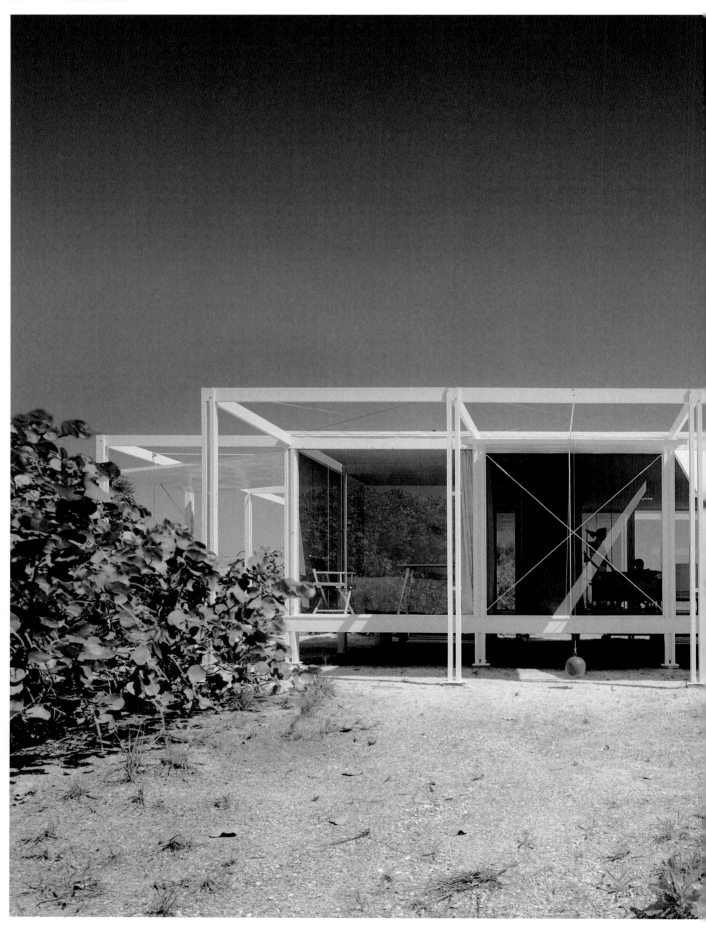

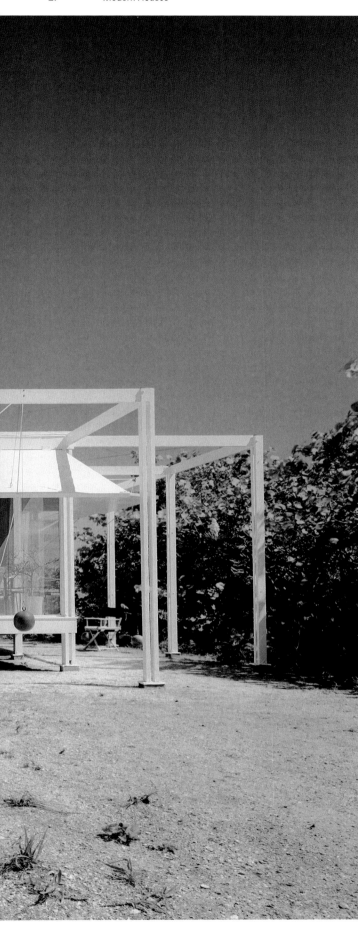

Fig. 10 Walker Guest House, Sanibel Island, Florida, 1952.
Photograph by Ezra Stoller for *House Beautiful*

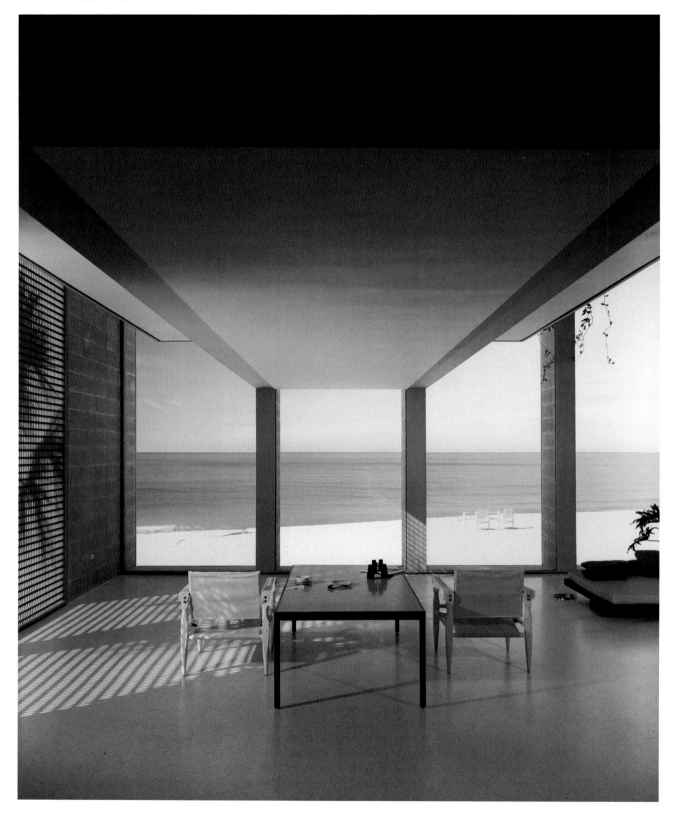

Fig. 11 Interior of the Deering Residence, Casey Key,
Florida, with a view of the beachfront, in 1958.
Photograph by Ezra Stoller

spider in the sand," a further nod to the local context of the guest house.[31] Like Mies's Farnsworth House and Johnson's Glass House, Rudolph's beachfront experiment was a pioneering study in the flow between interior and exterior volumes. However, by offering its occupants flexibility in the configuration of the space according to various conditions, the Walker Guest House was also a provocative critique of the orthodoxy of International Style modernism epitomized by those other projects, which soon became infamous for their resolutely static nature and unrepentant transparency.[32]

Rudolph was a fervent advocate for regionalism within modern architecture, something he felt was glaringly absent from the one-size-fits-all doctrine of the International Style, which he criticized for its tendency to "simply [say] 'let's have light' without controlling it psychologically."[33] A few years after the completion of the Walker Guest House, he published "Regionalism in Architecture," a polemical article in which he cited this project as a key example of how architecture should respond to the needs of people and the specifics of place. After acknowledging that, like the Farnsworth and Glass Houses, his guesthouse also presents "interior manipulation of space [that] is free of the skin," he explains how his project diverges, perhaps offering something more dynamic, even humane and empathetic: "With all the panels lowered the house is a snug cottage, but when the panels are raised it becomes a large, screened pavilion. If you desire to retire from the world you have a cave, but when you feel good there is the joy of an open pavilion"[34]—or "gold-fish bowl," to return to one of Rudolph's metaphors. Each of Rudolph's Florida houses takes a distinctive approach to mediating the relationship between interior and exterior spaces (fig. 11).

In later years, Rudolph returned to the residential typology as a place for experimentation, often at a larger scale and usually enabled by bold clients who entrusted his ambitious vision with large budgets. For example, the Bass Residence (1970, fig. 12), the largest of Rudolph's built single-family residential projects, extends the Walker Guest House's exploration of free-flowing architectural space to an expansive site in Fort Worth, Texas. Instead of humble wood painted white, Rudolph spared no expense when selecting materials, opting for

structural steel and white porcelain-coated aluminum panels. Like Rudolph's earlier houses, the Bass Residence engages evocatively in a spatial relationship with its environment; a complex composition of immense horizontal floating planes, it seems to almost levitate above the landscape. Around the same time, Rudolph completed the Green Residence (1968–72, fig. 13) in Pennsylvania, which was originally designed to be assembled from factory-made, foldable modules individually transported to the building site by road. Although construction delays and budget constraints eventually necessitated using a more traditional frame structure, the finished project visually conveys the philosophy behind Rudolph's initial concept, sitting on a grassy hill like "a spacecraft poised in interrupted motion."[35]

Although Rudolph continued to design private houses, in the late 1960s his residential work pivoted toward multiunit communities. Taking up the challenge of the housing crisis affecting major cities in the Northeast, he secured a series of public commissions that allowed him to develop residential projects in urban settings and on a much larger scale than he had previously imagined.

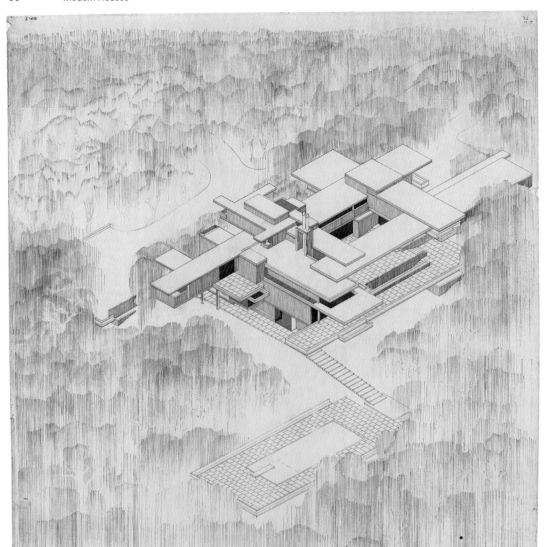

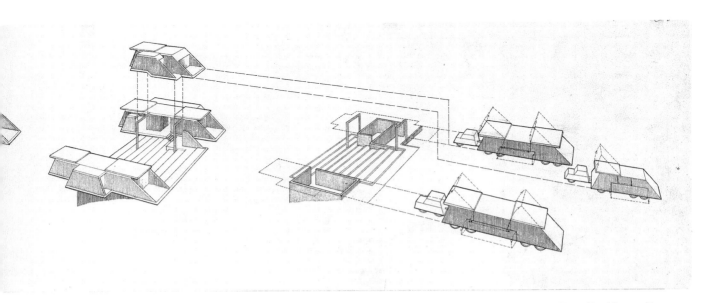

Fig. 12 Isometric drawing of the Bass Residence, Fort
 Worth, Texas, 1970
Fig. 13 Perspective drawing studies showing prefabri-
 cated modular assembly for the Green Residence,
 Cherry Hill, Pennsylvania, 1989 (built 1972)

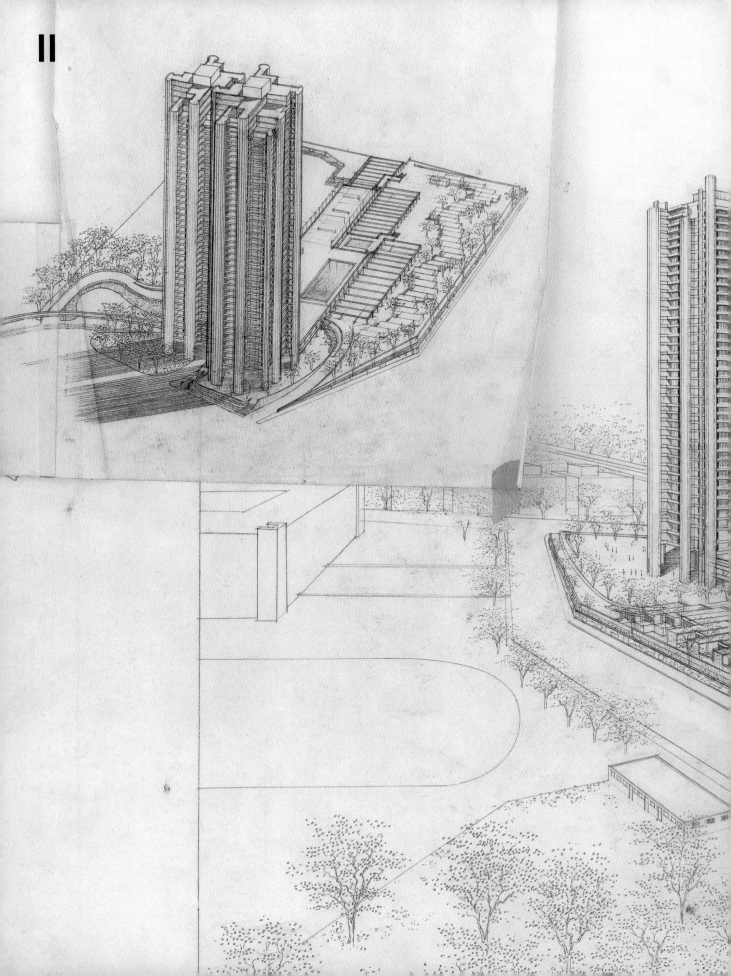

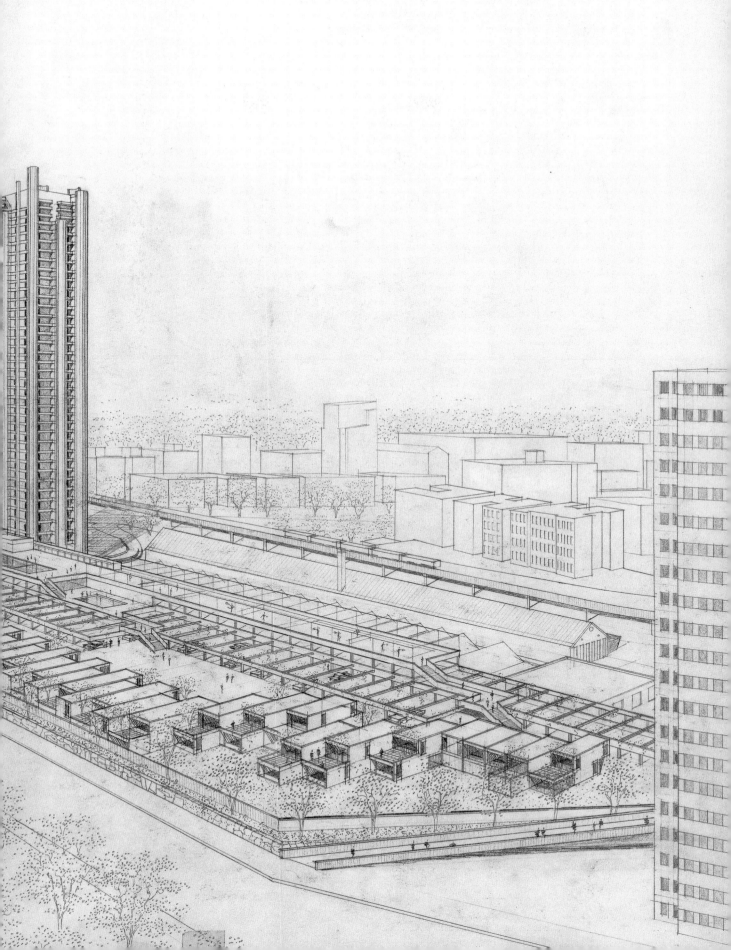

II URBAN RENEWAL

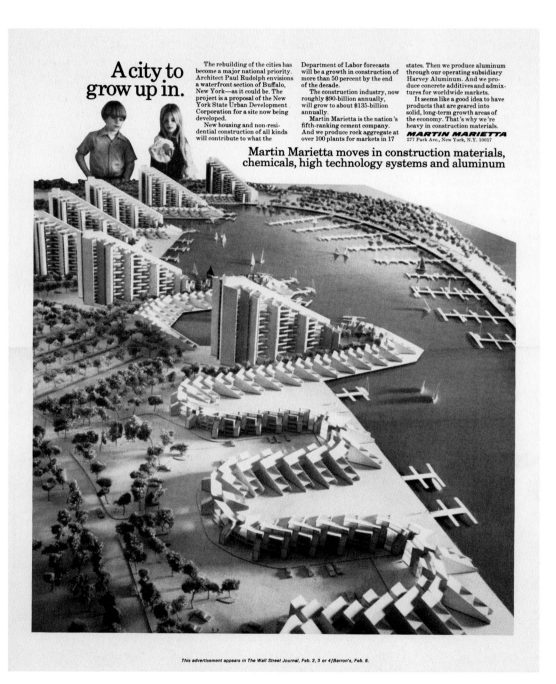

A city to grow up in.

The rebuilding of the cities has become a major national priority. Architect Paul Rudolph envisions a waterfront section of Buffalo, New York—as it could be. The project is a proposal of the New York State Urban Development Corporation for a site now being developed.

New housing and non-residential construction of all kinds will contribute to what the Department of Labor forecasts will be a growth in construction of more than 50 percent by the end of the decade.

The construction industry, now roughly $90-billion annually, will grow to about $135-billion annually.

Martin Marietta is the nation's fifth-ranking cement company. And we produce rock aggregate at over 100 plants for markets in 17 states. Then we produce aluminum through our operating subsidiary Harvey Aluminum. And we produce concrete additives and admixtures for worldwide markets.

It seems like a good idea to have products that are geared into solid, long-term growth areas of the economy. That's why we're heavy in construction materials.

MARTIN MARIETTA
277 Park Ave., New York, N.Y. 10017

Martin Marietta moves in construction materials, chemicals, high technology systems and aluminum

This advertisement appears in The Wall Street Journal, Feb. 2, 3 or 4/Barron's, Feb. 8.

Fig. 14 Advertisement for Martin Marietta concrete company, "A city to grow up in," featuring an architectural model of the Buffalo Waterfront redevelopment project (partially demolished), Buffalo, New York, ca. 1970

As early as the mid-1940s, architects had begun to seek alternatives to International Style modernism, arriving at what the architect Louis Kahn described as a muscular architecture that "conveys the feeling of its eternity."[36] At this same time, Le Corbusier was pioneering his approach to *béton brut*, or raw concrete, exemplified by his Unité d'habitation housing project (1947–52) in Marseille, with its "brute," unfinished concrete details—a model that would later inform Rudolph's textured concrete surfaces on the exterior and interior of the Art and Architecture Building at Yale. During the 1950s Reyner Banham popularized the term "Brutalism," a moniker that quickly became attached to much of the postwar architecture rising in Europe, which was producing, to borrow a phrase from Le Corbusier, a "massacre of concrete."[37] It was a far cry from the functionalism of the Walker Guest House, with its minimal, linear framework, but this new monumental style became Rudolph's preferred toolkit for his larger civic projects during the 1960s and 1970s, including his public-housing schemes.

As the journalist Michael Snyder observed many years later, "Where Modernism was poised and polite ... Brutalism evolved into something bold and confrontational, its heavy, rugged forms forged of new industrial materials that disguised nothing at all."[38] The style came to prominence across much of North America at the same time as the growing impetus for urban renewal that emerged in the years after World War II. Beyond its consideration as simply a style, Brutalism was increasingly seen as an appropriate and timely architectural methodology for the execution of these hugely ambitious public projects. Conceived at a vast scale, these divisive and controversial initiatives entailed demolishing entire neighborhoods and replacing them with buildings that sometimes employed experimental forms and untested materials, such as concrete.[39] Originally prompted by the U.S. Housing Act of 1949, which authorized extensive federal loans, the nationwide housing redevelopment program was intended to address urban decay by improving housing conditions and creating a more balanced distribution of density for economically disadvantaged residents.[40] However, these contentious schemes required public-private partnerships with major developers, and the rapid clearance of supposedly "blighted areas" in order to create "higher-class housing" often disproportionately affected long-established low-income communities of color who were permanently displaced through forced relocation and eminent-domain property purchases; urban "renewal" soon became synonymous with urban "removal."[41]

The major design commitments of the urban-renewal program dovetailed with Rudolph's own goals in all facets of his career, especially his residential work: for example, "reestablishing urban monumentality, unwaveringly promoting Modernism, acknowledging the importance of the automobile in the next-generation city, and applying the latest technological tools to make housing affordable—particularly through prefabrication."[42] His Shoreline Apartments (1969–74), part of a mixed-use scheme to redevelop Buffalo's Lake Erie waterfront, was an early flagship project from New York State's Urban Development Corporation (UDC), an agency established by Governor Nelson Rockefeller to fast-track the creation of badly needed subsidized housing and other urgent civic infrastructure.[43] As an illustration of how these projects galvanized national industry and captured the public's imagination, Martin Marietta, one of the leading cement companies at the time, took out a full-page advertisement in the *Wall Street Journal* that depicts two young children studying Rudolph's large-scale site model of the Buffalo project below the compelling tagline, "A city to grow up in" (fig. 14). The copy declares that "the rebuilding of the cities has become a major national priority. Architect Paul Rudolph envisions a waterfront section of Buffalo, New York—as it could be."[44] It is likely that the photograph of the Buffalo model was staged in a gallery at the Museum of Modern Art, which at the time, during the winter of 1970, was hosting *Work in Progress*, an architecture exhibition featuring current projects by Philip Johnson, Kevin Roche, and Rudolph. The original UDC commission required the creation of 2,750 units of housing (mostly for low- and moderate-income residents), a school, community facilities, and even a marina—all aimed at reactivating previously unused land downtown. However, only the Shoreline Apartments section was completed, and much of it has since been demolished.[45] The housing units that were built represented one of Rudolph's

earliest attempts to apply the megastructure model to a housing typology, with tightly clustered blocks featuring his characteristic "corduroy" textured concrete on the exterior walls. A combination of private and communal outdoor spaces was achieved through projecting balconies, enclosed garden courts, and large shared green zones created from the thresholds in between the curves of the megastructure's overall serpentine form.[46] In the press release for the *Work in Progress* exhibition, MoMA's Director of Architecture and Design, Arthur Drexler, heralded Rudolph's buildings "for their complexity, their sculptural details, their effects of scale, and their texture.... All of them are designed to suggest human use, affording both inhabitants and passersby a kaleidoscopic variety." He described the Buffalo development as "a total configuration related to the natural landscape," observing that the buildings "seem to combine into a mountain range."[47]

In addition to the Buffalo Waterfront project and others that involved reintegrating unused land into an adjoining segment of the urban fabric, Rudolph also had the opportunity to conceive a handful of so-called New Town projects, starting with a blank canvas on relatively greenfield sites that were purchased either by private developers or through federal funding. Two of these commissions (both unrealized)—Fort Lincoln, a public-housing scheme (see figs. 35, 36), and Stafford Harbor, a private development (fig. 15)—were planned for the suburban belt surrounding Washington, DC. During the 1960s and 1970s this area witnessed rapid urban expansion and population growth, in no small part due to the Great Migration of African American communities from the South that created an urgent need for good-quality housing.

The Stafford Harbor project (1966) attracted particular attention. In the space of just four months in 1967 Rudolph's proposal was featured in *Architectural Record*, *Art in America*, and the *New York Times Magazine*—evidence of how Rudolph's public visibility (and public-relations savvy) allowed him to break beyond the confines of the architectural press. The master plan for the Stafford Harbor resort community, sited in Virginia on the Potomac River, approximately forty miles south of Washington,

DC, incorporated townhouses, apartments, commercial buildings, a hotel, and a marina, all for a projected population of around 35,000. The developer envisioned regional transportation along the Potomac using hydrofoils and hovercraft, making Stafford Harbor appealing as both a commuter suburb and a retirement community.

Conscious of the attractive proposition of living nestled in an extensive rolling landscape, Rudolph was sensitive to keeping the rhythm of the surrounding terrain intact as much as possible when planning the site. In a megastructure configuration, he stacked dense clusters of ziggurat-shaped housing blocks along the topographical contours of the hills, exaggerating the peaks and valleys. To prevent cars from marring the landscape, he routed traffic underneath the buildings and through the hillside.[48] (He employed a similar tactic, though tailored to an urban setting, in his Lower Manhattan Expressway megastructure project [see figs. 44–47], which he was developing at roughly the same time.) The Stafford Harbor proposal expressed Rudolph's utopian vision on a vast scale, as is apparent in the huge landscape model for the project, which for several years dominated the entrance lobby wall of Rudolph's New York office (see fig. 50). The towering model even featured prominently on the *Times Magazine* cover, where it utterly dwarfs Rudolph, who seems on the verge of being swallowed whole by the "jaws" of the curving marina jetties in the ambitious scheme (fig. 16).[49] In an interview for *Art in America*, Rudolph reflected on the rare opportunities afforded by this project: "You very seldom work on an entire town, and this is the first time I've ever done it. The magnitude you're dealing with makes for different concepts.... I really think of this as a continuation of the land."[50]

Shortly after working on the Stafford Harbor master plan, Rudolph had the opportunity to design a major public-housing project in New York City, Tracey Towers (1967–72, fig. 17). It was a product of the postwar Mitchell-Lama housing program in New York State, which enabled the construction of affordable residential co-op buildings for middle-income tenants, who would own shares in the building's corporation and hold proprietary leases to their units. A rare example of an extant Rudolph project in

the city, it has since been heralded as an "exuberant departure" from typical public-housing developments of the period and "perhaps New York's ultimate example of futuristic design."[51] Under the provisions of the state-subsidized housing program, the land for the project was acquired through eminent domain and handed over to private developers. Additionally, Rudolph was able to utilize the air rights above an adjacent storage yard for subway trains, in his words, "simultaneously eliminating a Twentieth Century eyesore and creating a man-made plateau within the New York City area which gives a sense of community and identity."[52] Although never fully realized, this proposed platform was intended for townhouses and recreational facilities composed of stacked, interconnected, modular units, as well as what Rudolph described as "the contemporary phenomenon of a garden with air space under it."[53]

Tracey Towers is notable for its exterior curved walls that "sent corduroy concrete shooting forty stories into the air."[54] As Rudolph explained, the walls were "not curved for structural reasons at all, but because the site plan and traffic movement dictated an easing of the corners," adding that they were designed "to lead the eye around the towers, thereby emphasizing their three-dimensionality."[55] The visual richness and complexity of these curves resulted in floor plans "that suggest palm fronds drawn on a child's Spirograph."[56] At the time, Tracey Towers was considered groundbreaking in its potential to offer a new path forward for public housing, as indicated by a double-page advertisement that appeared in *Business Week* during the summer of 1969 with the provocative tagline, "What bureaucrats should know about the difference between public housing and architecture" (fig. 18). A promotion for a recent study conducted by *Architectural Record*, the spread features an image of Rudolph's Tracey Towers model balanced precariously on a set of rail tracks, likely a dramatic illustration of the air-rights purchase that enabled the scheme in the first place. The accompanying text pulls no punches in its criticism of previous public-housing policies but celebrates Rudolph's forthcoming project as "beating the system [and looking] like anything but a government-aided housing project" with its ability to "break the deadlock between economy and good design in public housing," before finally noting, bitingly, that previous housing schemes had been the result of "a plethora of standards [and] regulations … which eliminates the very good as well as the very bad, and elevates mediocrity."[57] This barbed description of "too many bureaucrats spoil[ing] the mortar"[58] would have resonated with Rudolph—someone who always resisted the urge to expand the size of his architectural office even as the prestigious projects piled up.

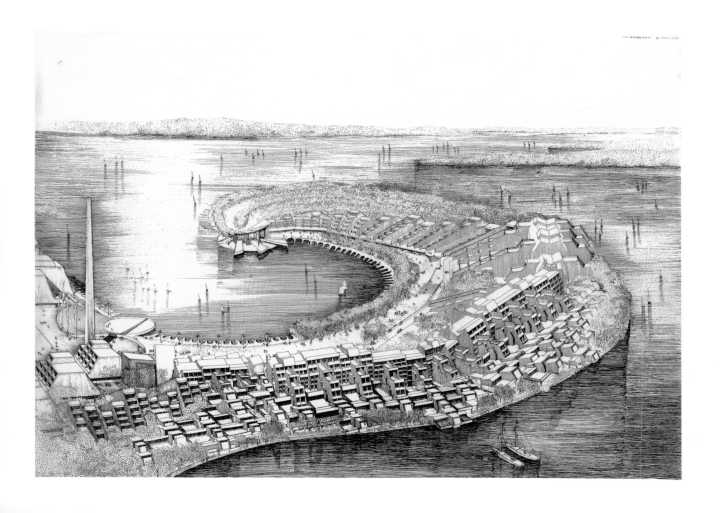

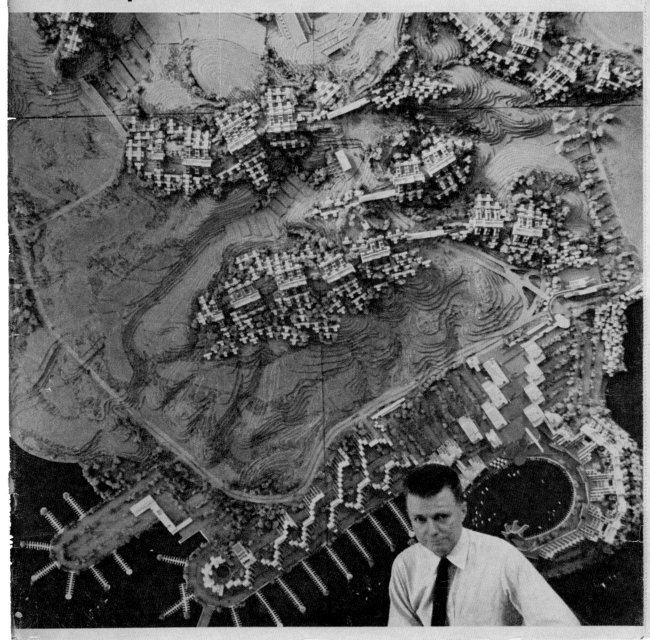

The New York Times Magazine

MARCH 26, 1967 SECTION 6

Architect Rudolph and His Town-To-Be

Contents—Page 21

Fig. 15 Aerial perspective drawing of the Stafford Harbor residential project (unbuilt), Virginia, 1966

Fig. 16 "Architect Rudolph and His Town-To-Be," cover story for *New York Times Magazine*, March 26, 1967, depicting Rudolph in front of his Stafford Harbor model

Fig. 17 Aerial perspective drawing of the Tracey Towers
 housing project, Bronx, New York, 1967
Fig. 18 Advertisement for McGraw-Hill Publications,
 "What bureaucrats should know about the differ-
 ence between public housing and architecture,"
 featuring the Tracey Towers project, 1969

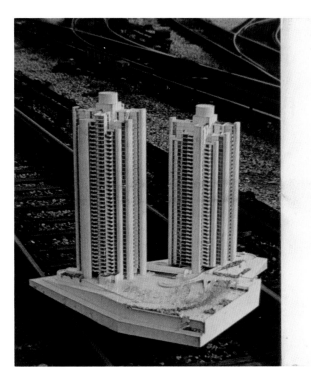

What bureaucrats should know about the difference between public housing and architecture.

Tracey Towers, seen to rise above a trainyard in the Bronx, is beating the system. It will look like anything but a government-sided housing project—which, in fact, it is. Yet it will cost little more than the cookie-cutter structures of most public housing.

Earlier this year, McGraw-Hill's Architectural Record reported on New York City's efforts—Tracey Towers among them—to break the deadlock between economy and good design in public housing.

As Architectural Record's editors bitingly noted, most public housing was the result of a plethora of standards, regulations, and reviews which "eliminates the very good as well as the very bad, and elevates mediocrity." In other words, too many bureaucrats spoil the mortar.

It takes more than courage to sit at a drafting table with that dismal record in mind. But New York's planners and designers—with a mandate from the city administration—are off to a dazzling start.

Of the nine new housing and environmental plans covered in Architectural Record's study, not one is mediocre; each demonstrates a humanism usually depressingly absent from government housing; all are as handsome as they are economical.

For years now, architects and planners have been tantalizing the stubborn city dweller with a new vocabulary of architecture. Words that summon up a vision of the city as it ought to be.

Townhouses. Pedestrian streets.

Underground parking. Terraces. Facilities for the elderly. Duplexes. Quiet. Outdoor cafes. Roof gardens. Spectacular views.

The trouble has been that the only place the urbanite could find a place to live which matched the new vocabulary was among the "luxury" listings of the real estate want ads. The low- and middle-income groups were left out in the cold.

But, as Architectural Record's survey shows, things are beginning to change at long last. In Tracey Towers, for example, some residents will have a magnificent view of the Manhattan skyline from their terraces while others can putter in the gardens of the townhouses below.

In other projects, architects are reviving such design variations as bay windows and French doors. Each project, moreover, is meant to fit into a community rather than replace it. The one new project is an unused trolley-barn. Others, like Tracey Towers, are being built on air-rights sites over trainyards. None require demolishing existing neighborhoods. The bulldozer is kept on a leash.

Obviously, New York still has a long way to go in its war against architectural mediocrity. But its recent victories are giving substance to the daydreams of those hundreds of thousands who have been filed away for so long in boxes designed by bureaucrats.

At least there is hope that New York City can save itself after all. And if New York can do it, why can't other cities?

McGRAW-HILL PUBLICATIONS

A good society is good business.

Architect: Jerald L. Karlan. Design architect: Paul Rudolph.

This advertisement appears in: Advertising Age, July 28; Business Week, August 16; Industrial Marketing, October; Sales Management, September 1, 1968.

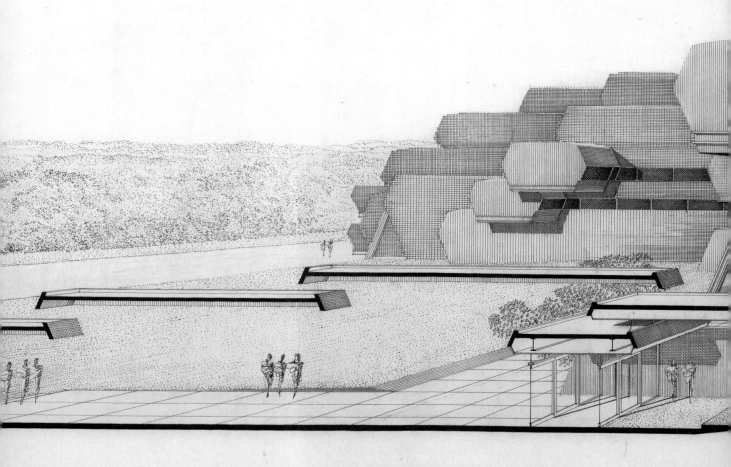

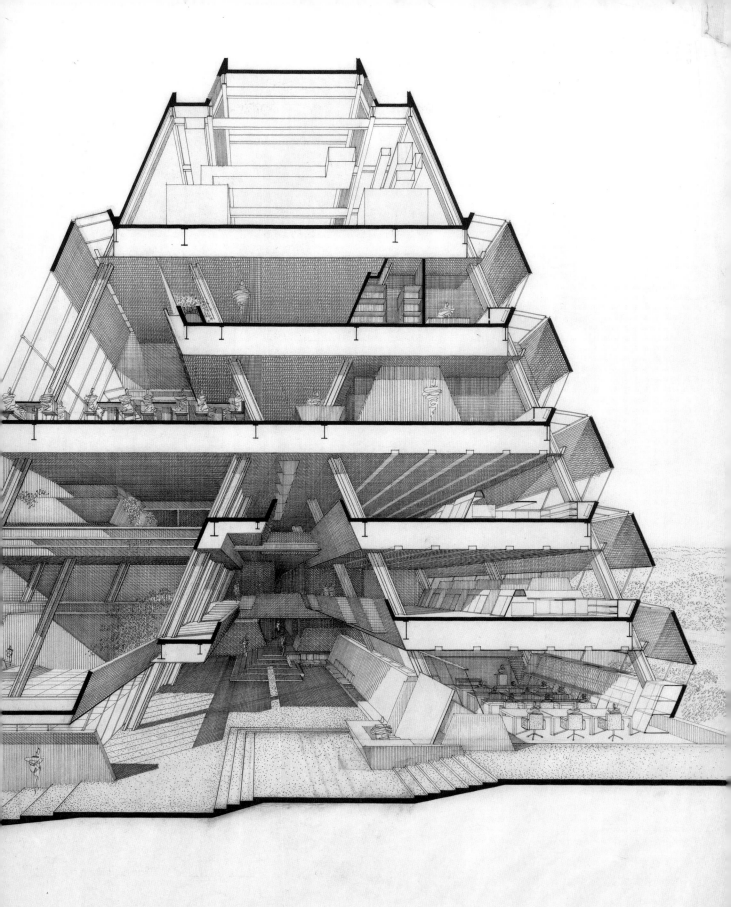

III CIVIC CAMPUS

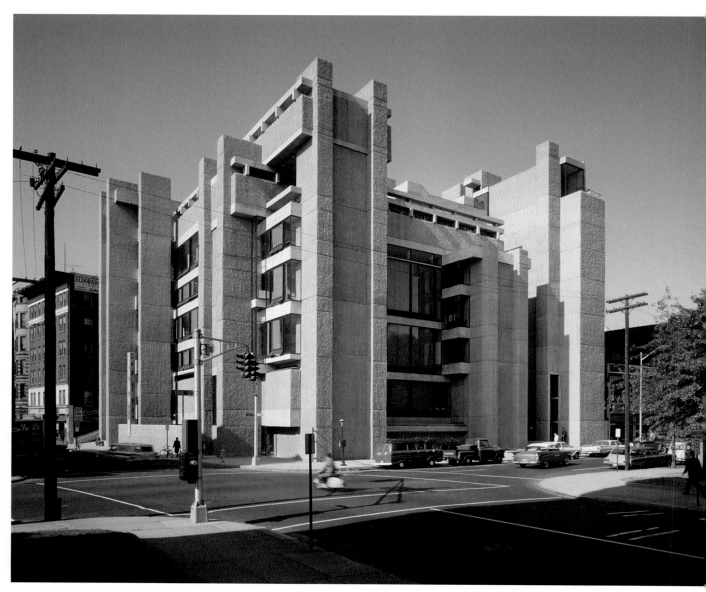

Fig. 19 Art and Architecture Building, Yale University,
New Haven, Connecticut, 1958–63. Photograph
by Ezra Stoller

Rudolph preferred to run his practice as an atelier environment where he could maintain control of all the key design decisions. Beyond the confines of the studio, his talent for networking and skillfully navigating bureaucracy became his personal superpower in the 1960s, when he was working on a stacked roster of major civic, academic, and corporate commissions and was required to deal with government agencies, city councils, university boards, and business leaders. His training in this arena started at the very beginning of his professional life when he witnessed the immense scale of production—and correspondingly bureaucratic processes—while serving at the Brooklyn Navy Yard. He recalled "seeing how 75,000 workers were organized.... I discovered red tape and learnt how to circumvent it. The game of deflecting existing forces started early."[59]

After arriving in New Haven, Rudolph burnished his reputation by shaking up the architectural program at Yale and designing what became his professional calling card, the Art and Architecture Building (1958–63, figs. 19–21), to critical acclaim. The building could be considered a master class in sculpting architectural space, with its balance of solids and voids, its contrasts between low-ceilinged corridors and open, daylight-saturated halls, and its intricate interleaving of thirty-seven different floor levels within seven stories, all set against a backdrop of Rudolph's trademark textured and bush-hammered concrete. As the architect Joseph Esherick once wryly observed, "You couldn't go to the men's room without having a spatial experience."[60] Indeed, Rudolph conceived the building with movement in mind. The famous perspective section drawing of the building (fig. 21) demonstrates how he strove to "find a graphic means of indicating what's happening to the space.... [It] can move quickly or slowly. It can twist and turn."[61] On the interior Rudolph juxtaposed references to architectural history, such as plaster casts of ancient and Renaissance relief sculpture, with elements of tactility and delight, such as physical specimens of nautilus and scallop shells embedded in the concrete. These elements imbued his resolutely modernist statement with the "frivolities and pluralities of postmodern thinking."[62]

When it opened in 1963, the Art and Architecture Building received extensive coverage in both the architectural and mainstream press, and, although it cemented Rudolph's place in the national conversation around modern architecture, it divided opinion from the beginning. Among other criticisms, the controversial building was panned for its lack of attention to certain core functional needs, especially those of the fine art students who shared the space with the architecture program. Just a few months after the building's dedication, Charles Jencks, then a graduate student at Harvard who would later become one of the leading theorists on postmodernism, wrote an excoriating review, titled "Esprit Nouveau est mort à New Haven, or Meaningless Architecture," in which he stated, "The intersection of planes, the exposing of massive concrete, the dark shadows, will always attract the eyes—until the eyes are so tired by exaggeration and continuous deceit that they are blinded."[63] Even before the official opening, students had sarcastically described the "'monastic seclusion' of the ambiguously walled library, with its 'restful dayglo-red-orange carpets so conducive to study and meditation.'"[64] Within just a few years, a visiting critic from *Architectural Forum* arrived to find concrete walls plastered with graffiti, cigarette butts stuffed into the holes left behind by the anchors for the formwork, and the statue of Minerva, standing imposingly over the drafting room, now with her eyes "blunked out [*sic*]," as if attacked by ravenous vultures.[65]

After a much-admired renovation in 2008 restored Rudolph's original vision, today the Art and Architecture Building is considered one of the clearest examples of his architectural philosophy, heralded for its "strong urban presence, expressionistic gestures and labyrinthine interiors."[66] However, during the late 1960s it was a highly visible target for the agitational forces moving against excessive monumentality, which culminated in the "Learning from Las Vegas" studio-seminar taught by Robert Venturi and Denise Scott Brown at Yale in 1968. With its focus on the advertising billboards and commercial strips of the vernacular suburban landscape, the course and its associated publication—now a landmark in postmodernist discourse—painfully picked apart Rudolph's Crawford Manor housing project in New Haven as an example of all that was wrong with so-called heroic, expressive, establishment architecture.[67]

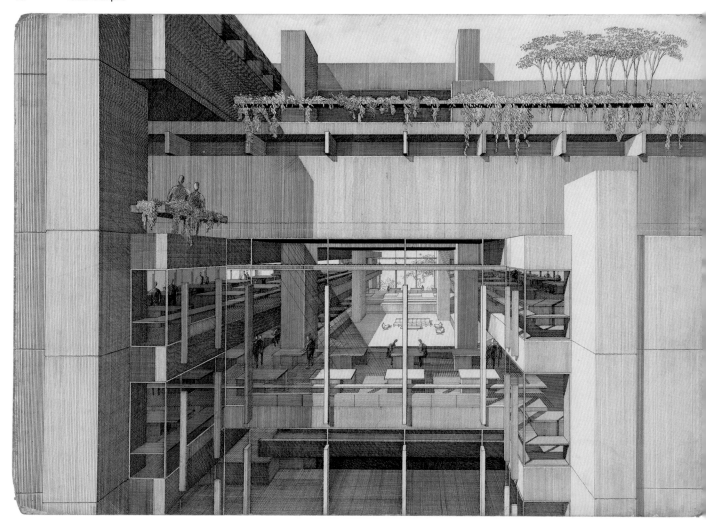

Fig. 20 Perspective drawing of the Art and Architecture
 Building, Yale University, New Haven, Connecticut,
 1958
Fig. 21 Perspective section drawing of the Art and
 Architecture Building, Yale University, New Haven,
 Connecticut, 1958

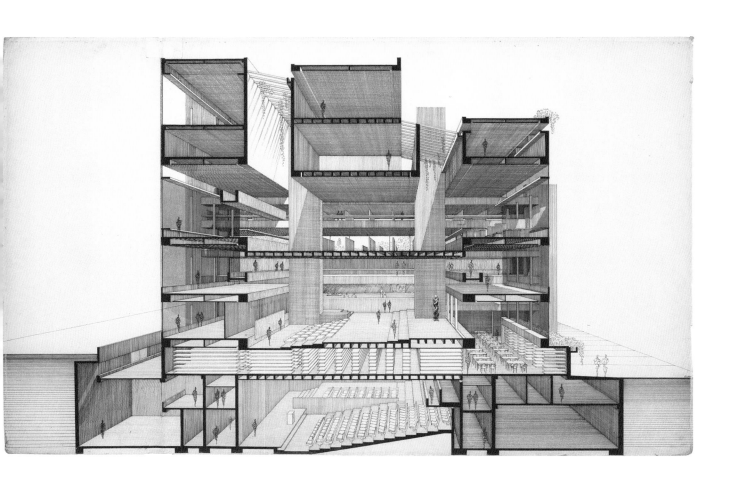

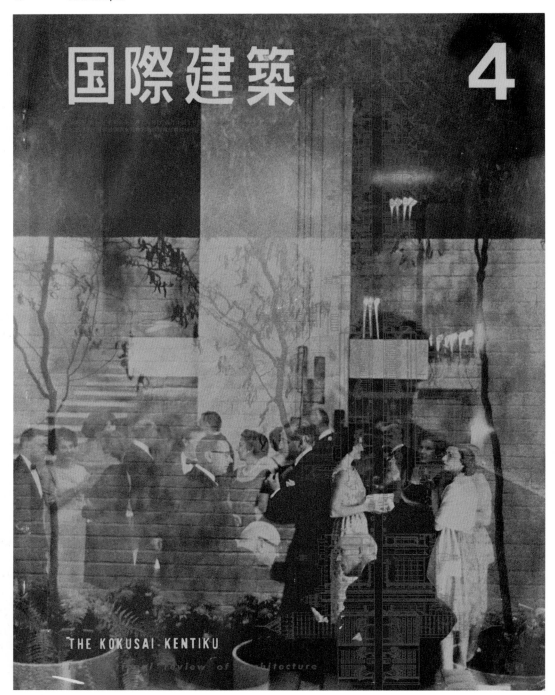

国際建築

4

THE KOKUSAI-KENTIKU

Fig. 22 Cover of the April 1965 issue of *The Kokusai Kentiku: International Review of Architecture*, showing a party at Rudolph's residence in New Haven, Connecticut, ca. 1962

Crawford Manor was among the notable public commissions Rudolph received from Edward Logue, an urban planner and public administrator with whom Rudolph developed several major projects during the 1960s, many of them involving urban renewal and civic infrastructure.[68] Throughout his career Rudolph benefited from cultivating strategic professional relationships, gaining the trust of key players who were deeply enmeshed within the spiderwebs of federal, state, and local planning and budgets. During his tenure at Yale he was known to host parties at his home that were attended by top university and city officials (fig. 22). The locales of Rudolph's projects for the public sector included New Haven, where Logue steered the New Haven Redevelopment Agency's efforts to create the nation's "model city" for urban renewal, receiving more federal dollars per capita than any other American city; Boston, where Logue, as head of the Boston Redevelopment Authority, invited Rudolph to work on the Boston Government Service Center; New York State, where Rudolph developed the UDC's Buffalo Waterfront project for Logue; and Washington, DC, where Logue was in charge of the urban design team that commissioned Rudolph's Fort Lincoln public-housing project.

Rudolph's Temple Street Parking Garage (1959–61, fig. 23) in New Haven is perhaps one of the more extreme examples of the perceived architectural hubris called out by Venturi and Scott Brown. Commissioned by Logue, this vast concrete structure, which stretches across two city blocks, was designed to serve 1,500 cars and originally formed part of a larger urban-renewal plan, featuring a hotel and a shopping mall (both unbuilt), intended to spark commercial activity in downtown New Haven. The garage project, Rudolph's first experience with federally funded urban development, coincided with his work on the Yale campus; at the time, both the city of New Haven and the university were important clients, providing commissions for both public and academic housing (see fig. 5), as well as laboratory research facilities. With its repeating large-span vaults that resemble the arches of a Roman aqueduct or the arcades of the Colosseum, the Temple Street Garage is a visually arresting ode to concrete, an elegant expression of the heft and texture of its construction materials. The original ambition,

astonishing to ponder, was to extend the building three times longer, creating a bridge over an existing highway that would connect two areas of the city with what Rudolph considered a "true megastructure,"[69] manifesting his beliefs that "the car is a generator of architectural form"[70] and that this parking garage "celebrates the automobile as the Roman stadium celebrated the chariot."[71]

Logue left for Boston in 1960, lured by the opportunity to replicate New Haven's urban-renewal strategies under Mayor John Collins's vision for a "New Boston" defined by modernist landmarks,[72] and he invited Rudolph along for the ride, commissioning him to design the Boston Government Service Center (1962–71). Like many city redevelopment plans of the period, the Boston master plan (centered around the new Boston City Hall) was the work of several architects, including Gropius, who designed a federal office building. Although initially brought in as a consultant, Rudolph soon spied an opportunity where "too many specialists and bureaucrats with overlapping authority created a vacuum which left the way open for an idea"[73]—again, deploying his razor-sharp skills to cut through red tape. Rudolph's concept for the master plan, adopted at the eleventh hour, was to "hollow out a concavity … a spiraling space like a conch"[74] to form a new public plaza that would be anchored by a central tower (unbuilt, fig. 24) and encircled by the main public resource buildings, including Rudolph's completed, albeit now under threat, Mental Health Building. As Rudolph scholar Timothy Rohan has pointed out, the public areas of the Boston project were an exercise in scenographic urbanism, with a central civic space modeled like an amphitheater and stagecraft flourishes such as projecting balconies, cascading concrete staircases, serpentine benches, and radiating textured lines that fanned out across the plaza (fig. 25).[75]

In the same period Rudolph embarked on two major campus projects: one academic, for the Southeastern Massachusetts Technological Institute, now known as UMass Dartmouth (1963–72, figs. 26, 27), and the other a research and administration building for a corporate client, the Burroughs-Wellcome Company Headquarters, in North Carolina (1969–72, figs. 28–30). Both typified the postwar model of the commuter

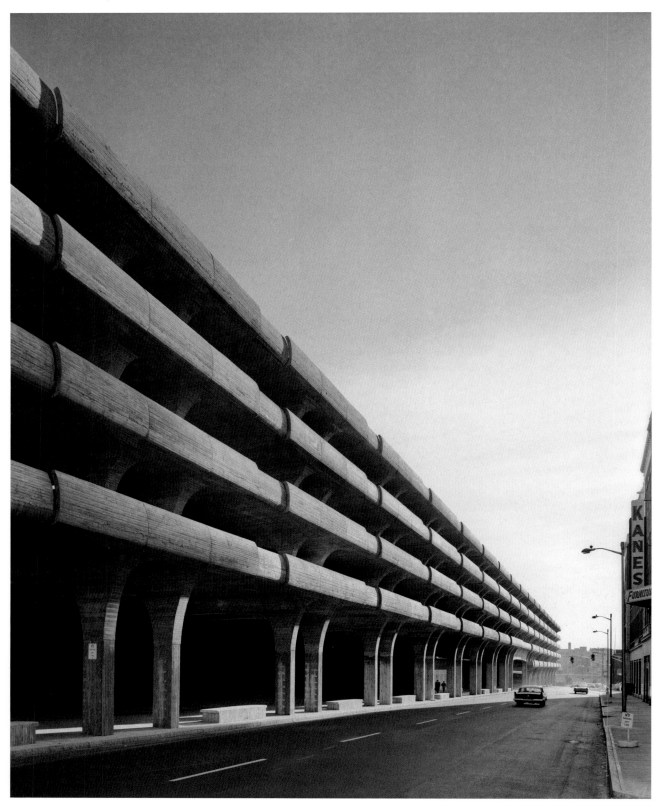

Fig. 23 Temple Street Parking Garage, New Haven,
Connecticut, in 1962. Photograph by Ezra Stoller

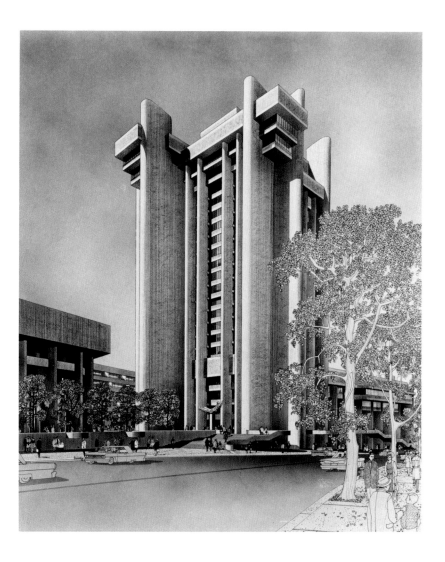

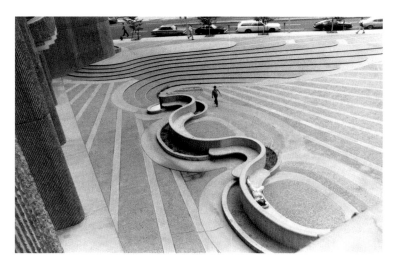

Fig. 24 Presentation rendering by Helmut Jacoby,
 depicting Rudolph's proposed tower (unbuilt) for
 the Boston Government Service Center, 1963
Fig. 25 Plaza and benches at the Boston Government
 Service Center, ca. 1966

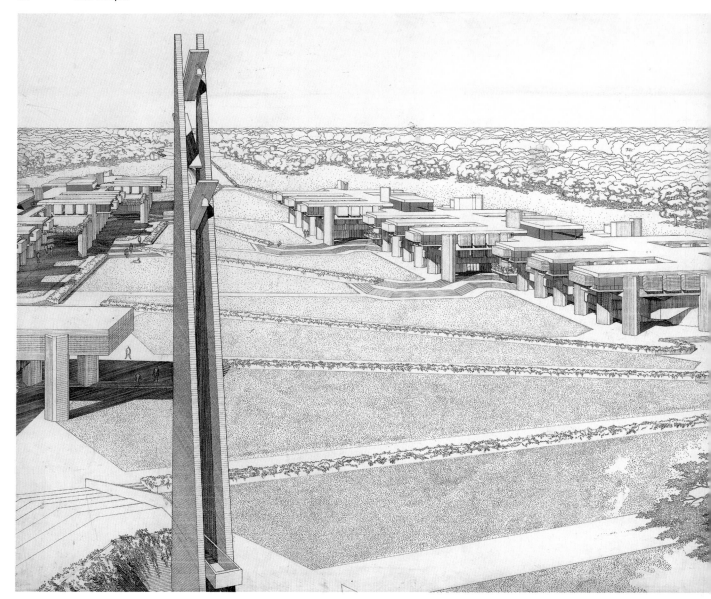

Fig. 26 Aerial perspective drawing of the Southeastern
 Massachusetts Technological Institute (SMTI,
 now UMass Dartmouth), North Dartmouth,
 Massachusetts, 1963
Fig. 27 Interior of the Southeastern Massachusetts
 Technological Institute (SMTI, now UMass
 Dartmouth), North Dartmouth, Massachusetts,
 in 1966. Photograph by Joseph Molitor

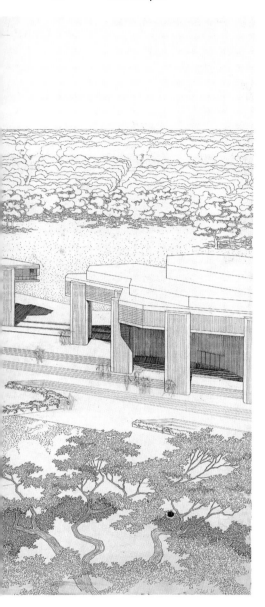

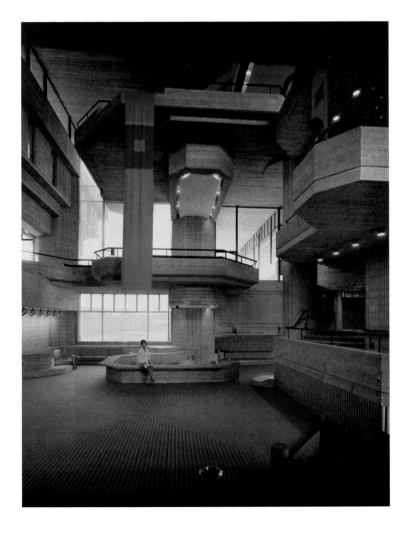

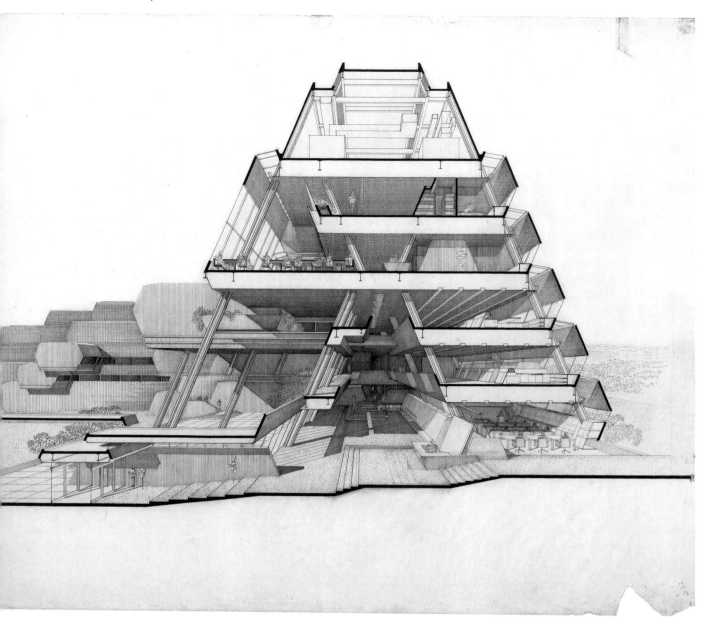

Fig. 28 Perspective section drawing of the Burroughs-
Wellcome Company Headquarters (demolished),
North Carolina, 1969–72

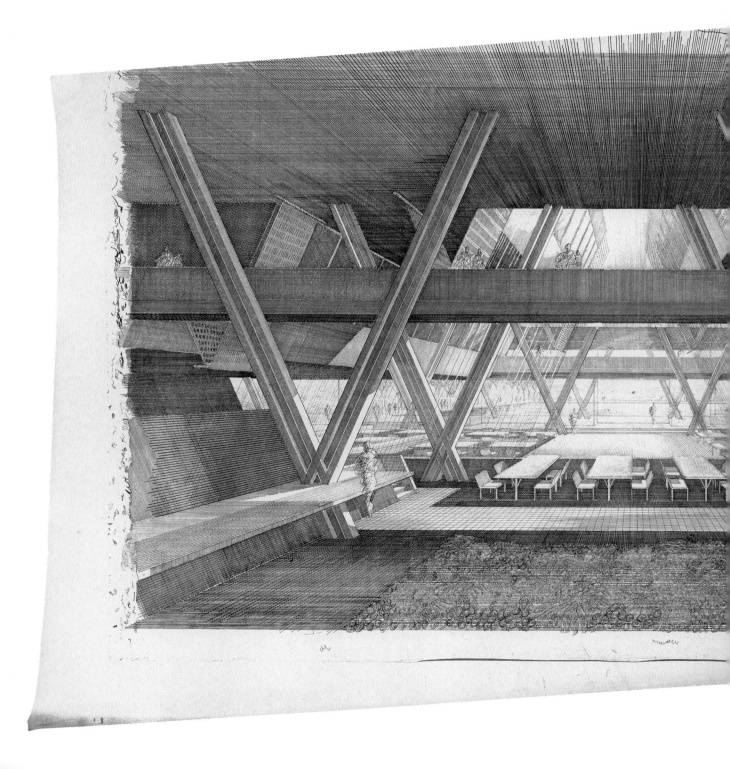

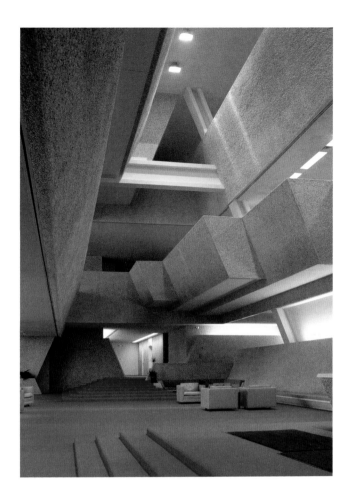

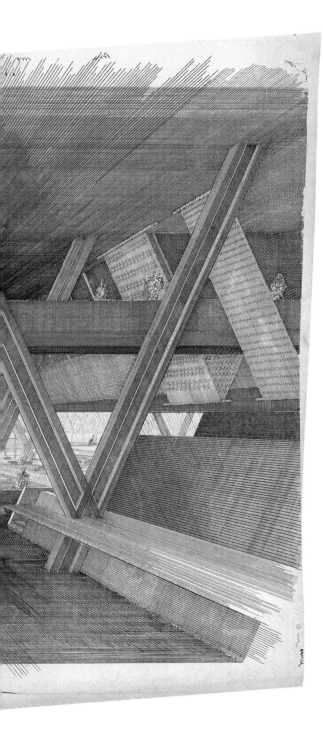

Fig. 29 Interior perspective drawing of the Burroughs-
 Wellcome Company Headquarters (demolished),
 showing proposed slanted textile hangings,
 1969–72
Fig. 30 Interior of Burroughs-Wellcome Company Head-
 quarters (demolished), in 1970–72. Photograph by
 G. E. Kidder Smith

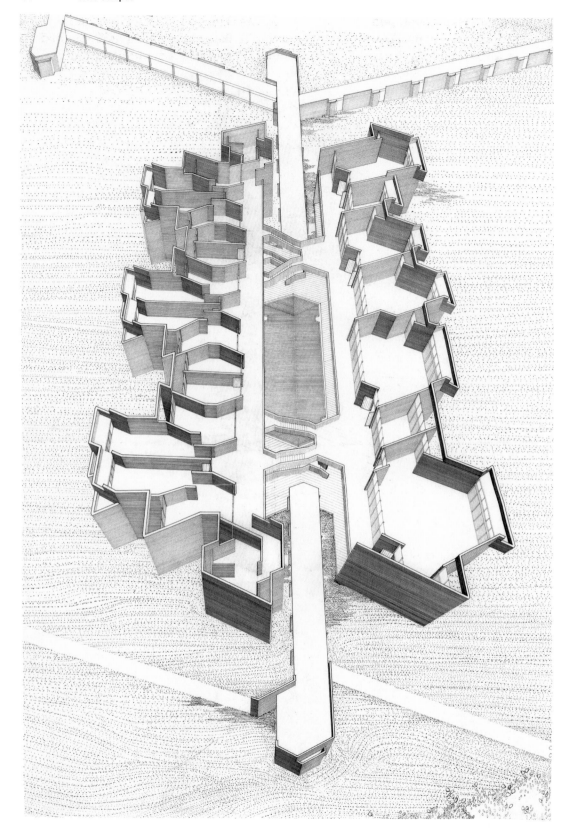

Fig. 31 Aerial perspective section drawing of East
Pakistan (now Bangladesh) Agricultural University,
Mymensingh, ca.1969

campus, occupying a previously undeveloped site outside a dense city context, and they were significant opportunities for Rudolph to develop a building methodology that could be applied to interconnected structures across a vast site. He would explore a similar strategy in his East Pakistan Agricultural University project (1965–75, fig. 31), a unique commission for Rudolph in South Asia, which was started before but completed after Bangladesh gained its independence. Rudolph described the SMTI campus as "a single building utilizing a single structural-mechanical system, to be constructed of one material,"[76] a statement that belies the bravura of the interiors of the SMTI and Burroughs-Wellcome projects, with their striking expressions of form and texture, balconies that appear to float, brightly colored hanging textiles, and carpets with stripes of red, purple, and orange that resonate with the surrounding ridges of concrete.[77] For many projects of this era, Rudolph collaborated with the interior designer Bill Bagnall, who was also responsible for the notoriously vivid orange carpet at the Art and Architecture Building. The aluminum-disc curtains in the SMTI common rooms, which "rippled continuously, filtering and reflecting sunlight and projecting changing shadows,"[78] seem to anticipate Rudolph's experimental interior design at his Beekman Place apartment in New York (see fig. 55).

One of Rudolph's most dramatically expressive interiors is his Chapel for the Tuskegee Institute (now the HBCU Tuskegee University, 1960–69, figs. 32, 33), which was a collaboration with the African American–led firm of Fry & Welch, steered by Major Holland, a Howard University architecture graduate. The commission was an opportunity for Rudolph to return to Alabama, where he had been an undergraduate at the Polytechnic Institute (now Auburn University). At the time, the chapel was celebrated for possessing "the power of Le Corbusier's Ronchamp [chapel],"[79] with skylights allowing a flood of natural illumination to descend from above. The internal structural geometries create a sense of the building "being alive and in motion,"[80] as scholars have noted, echoing Rudolph's own analysis of architectural energy flowing within the chapel and his ideas around "the psychology of the building [being defined by] the compression and release of space."[81]

By the time construction was completed on the Tuskegee Chapel in 1969, fire had gutted much of the Yale Art and Architecture Building, and Rudolph's brand of "heroic" architecture, as exemplified by these major civic, academic, and corporate commissions, was fast falling out of favor. The *Work in Progress* exhibition at MoMA the following year, which in addition to Rudolph's Buffalo Waterfront master plan also featured his Boston Government Service Center, SMTI, and Burroughs-Wellcome projects, was described by the esteemed *New York Times* architecture critic Ada Louise Huxtable as the "season's most fashionably hated show" because the buildings were considered "Establishment architecture."[82] However, included in the same exhibition was Rudolph's model for another large project, his Graphic Arts Center megastructure proposal—which revealed an alternative direction in research, design, and construction that he had been exploring during this same period.

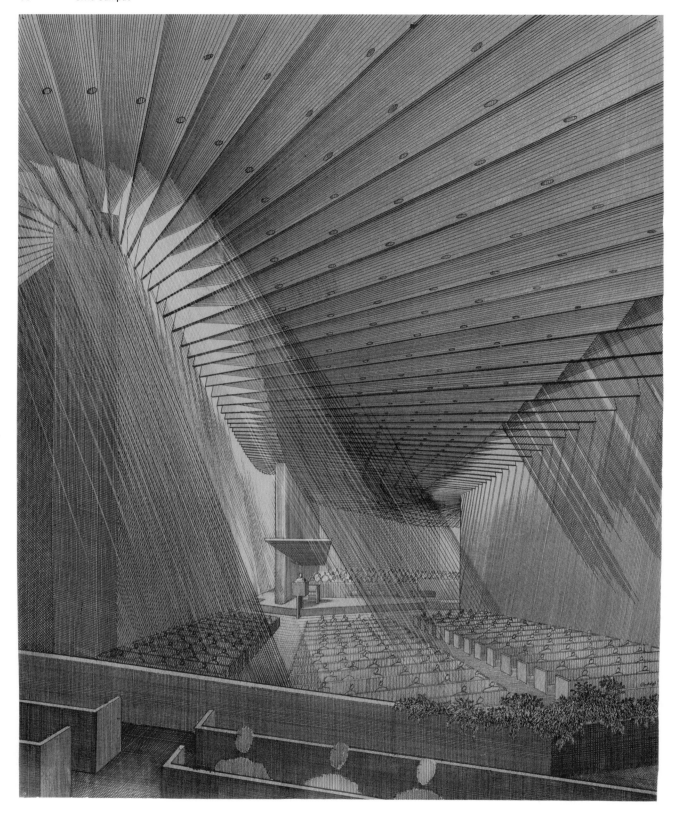

Fig. 32 Interior perspective drawing of Tuskegee Institute
 Chapel (now Tuskegee University), Tuskegee,
 Alabama, ca. 1960
Fig. 33 Interior of Tuskegee Institute Chapel (now
 Tuskegee University) in 1969. Photograph by Ezra
 Stoller for *Architectural Record*

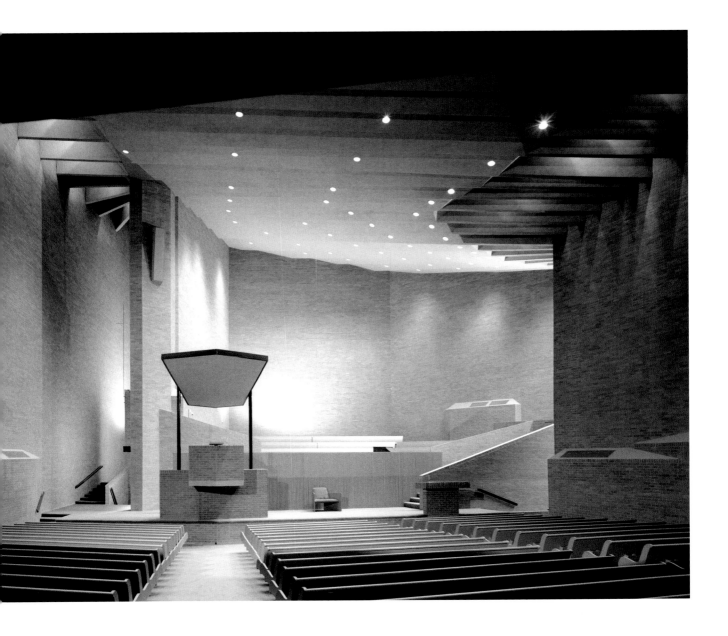

IV

IV MEGASTRUCTURES

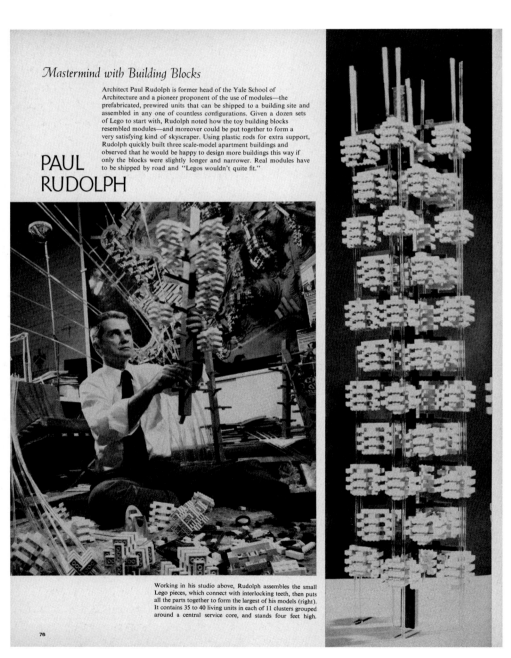

Fig. 34 *Life Magazine* feature, "Mastermind with Building Blocks: Paul Rudolph," December 15, 1972, depicting Rudolph experimenting with LEGO blocks to assemble a model, possibly related to the Graphic Arts Center project for New York City. Photographs by Yale Joel

From the very beginning of his career, Rudolph was fascinated with the possibilities of using industrial prefabrication to create new systems of construction and assembly that not only were more cost-efficient than conventional means but also unlocked the potential for building at a previously unimagined scale with new architectural forms. The resulting typology—the megastructure—was a large composition of prefabricated modules arranged to suit the programmatic needs of a building or complex of buildings (fig. 34). As early as 1954 Rudolph sketched a design for an apartment tower consisting of trailer-home-type modules suspended from four central supporting masts, anticipating later avant-garde projects such as the British group Archigram's radical Plug-In City proposal (1963–66) and the Japanese Metabolist architect Kisho Kurokawa's Nakagin Capsule Tower (1970–72). In various lectures and articles Rudolph often returned to this idea of the prefab mobile-home unit as the "twentieth-century brick," essentially a factory-assembled module that could be pre-fitted with plumbing, wiring, heating, and finishes, and then trucked in multiples directly to the construction site for installation, or "plugging in."[83] The modular units envisioned by Rudolph might be compared to shipping containers (also standardized, industrially produced units), which since the 1980s have been repurposed in architectural applications, including housing.[84]

During the late 1960s Rudolph applied these ideas to two housing projects: Fort Lincoln (1966–68, figs. 35, 36), an unbuilt New Town project commissioned by Edward Logue for Washington, DC; and Oriental Masonic Gardens (1969, figs. 37–39) in New Haven, which offered an alternative to existing substandard housing in the city's racially segregated neighborhoods but was demolished a little over a decade after its unveiling.[85] In both schemes, Rudolph stacked the modular units to create a compelling massing and urban density that evoked a hillside town, and then carefully arranged the thresholds between the unit clusters to allow for either private courtyards or shared green spaces.

These projects coincided with the launch of a federal program called Operation Breakthrough, which was intended to revolutionize residential construction through prefabricated housing units. Conveying the urgent need to improve the availability and quality of public housing, the senior administrators for the Department of Housing and Urban Development stated, "Apollo 11 demonstrated what can be achieved when American determination is concentrated on a specific goal … Yet year after year, we have failed to take up a national challenge which can no longer be ignored … to make our cities livable and to provide a decent home for every American … [and to] promote a pride of occupancy."[86] HUD secretary George Romney stressed that this was not "a program designed to see just how cheaply we can build a home but a way to break through to total new systems of housing construction and marketing."[87] Although neither of Rudolph's modular-housing projects were formally part of this federal program, it is significant to note how his long-held interests in prefabricated construction coincided during this period with a groundswell of commitment to seeking new future-focused and technologically enabled approaches to addressing the acute national housing crisis.

Rudolph adapted the concepts of modular construction on a more ambitious, urban scale in two huge megastructure projects for New York City, both of which attracted widespread press coverage—not all of it favorable—and remain visions on paper. For the Graphic Arts Center (1967, figs. 40–43), the Amalgamated Lithographers Guild of America invited Rudolph to design a vast mixed-use project incorporating office buildings, residential towers, an elementary school, restaurants, and industrial printing spaces that would straddle the West Side Highway and extend into the Hudson River. As if an augmented version of his 1954 Trailer Tower, each apartment tower in the complex consisted of clusters of "twentieth-century bricks" suspended from a central mast; at the time it was deemed in the popular press "one of the most beautiful and imaginative structures ever designed."[88] In the same article Rudolph referred to the project as a "city-within-a-city … crying out for acceptance today … [and] regarded in tomorrow's world as the obvious solution of urban problems," adding that he wanted to give all residents "not just a balcony but a full back yard, even if it is a back yard in the sky."[89] This project, which Rudolph scholar

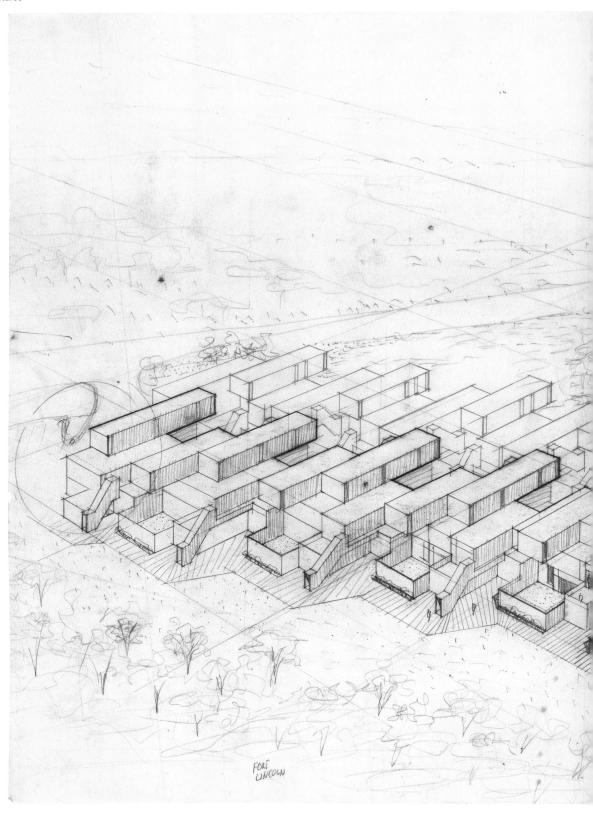

FORT
LINCOLN

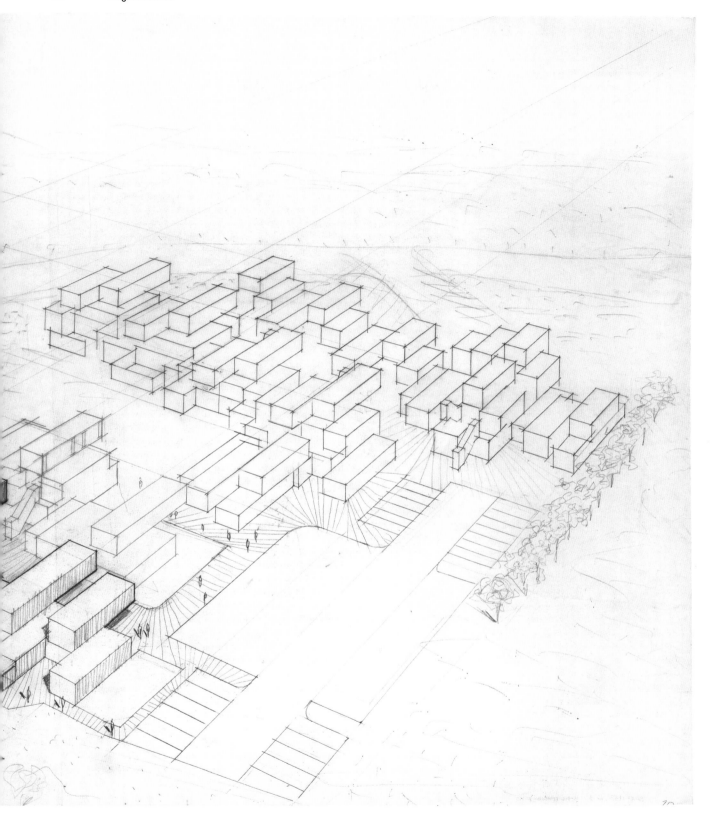

Fig. 35 Isometric site plan study showing an arrangement
of prefabricated units for the Fort Lincoln housing
project (unbuilt), Washington, DC, 1966–68

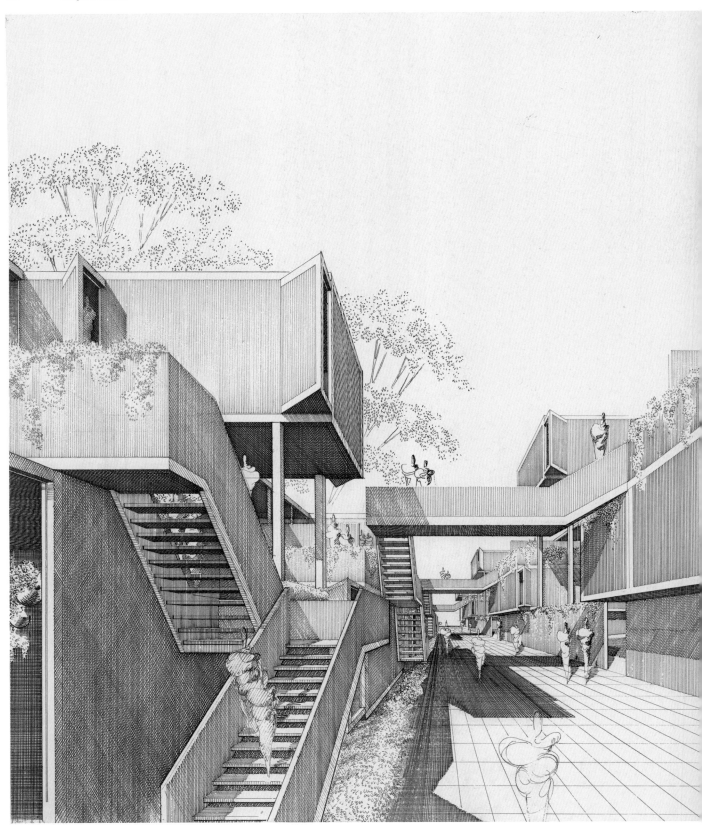

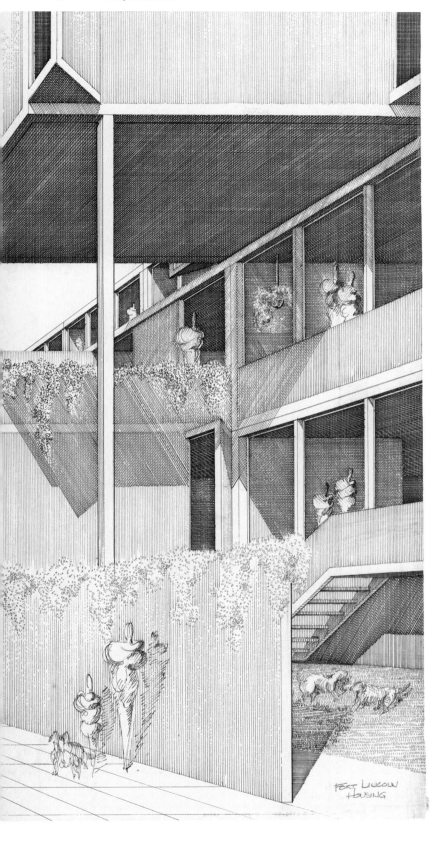

FORT LINCOLN
HOUSING

Fig. 36 Perspective drawing of the Fort Lincoln housing
project (unbuilt), showing walkways and other
communal and private spaces, 1966–68

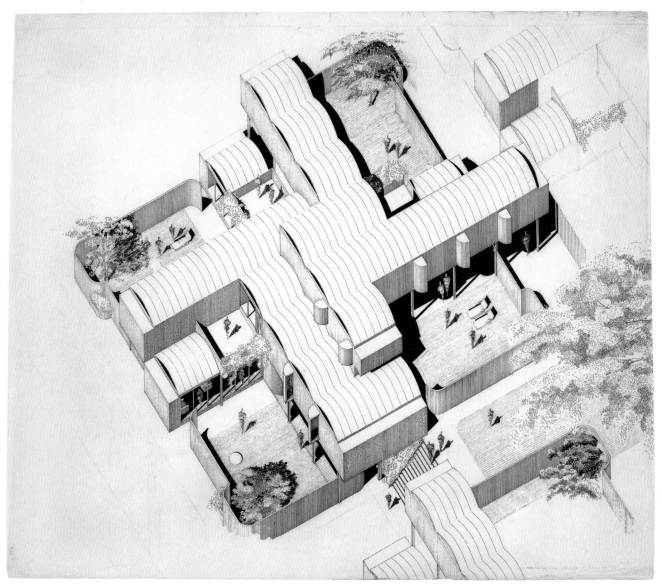

Fig. 37 Isometric drawing of Oriental Masonic Gardens
 (demolished), New Haven, Connecticut, 1968
Fig. 38 A crane lowering a prefabricated modular unit into
 place at Oriental Masonic Gardens (demolished),
 New Haven, Connecticut, ca. 1968
Fig. 39 Advertisement for the American Plywood
 Association, "Industrialized housing is not coming.
 It's here," featuring Oriental Masonic Gardens
 (demolished), 1968

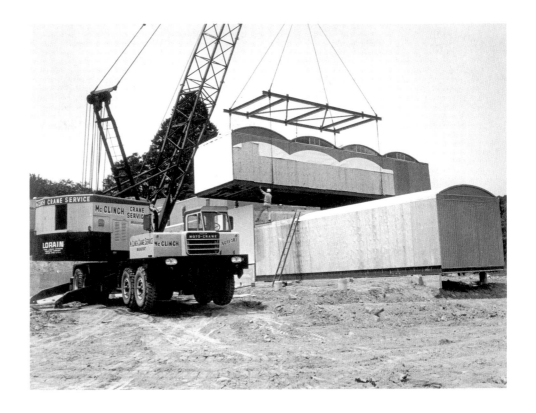

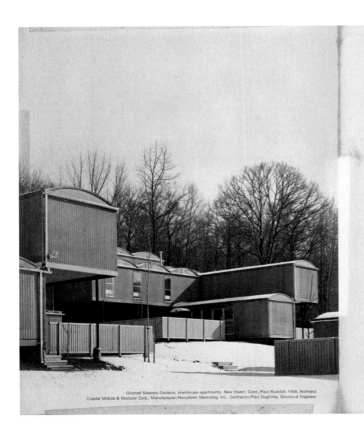

Oriental Masonic Gardens, townhouse-apartments, New Haven, Conn./Paul Rudolph, FAIA, Architect. Coastal Mobile & Modular Corp., Manufacturer/Hercoform Marketing, Inc., Contractor/Paul Gugliotta, Structural Engineer.

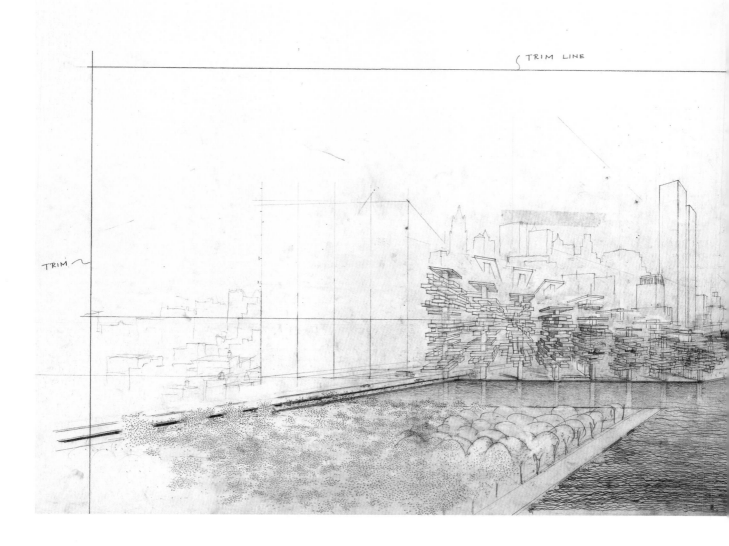

TRIM LINE

TRIM.

Fig. 40 Perspective study of the Graphic Arts Center
 project (unbuilt), New York, with the soon-to-be-
 realized World Trade Center towers in the
 background, ca. 1967
Fig. 41 Model for one of the towers in the Graphic Arts
 Center project (unbuilt), showing a vertical stack
 of prefabricated units, ca. 1967

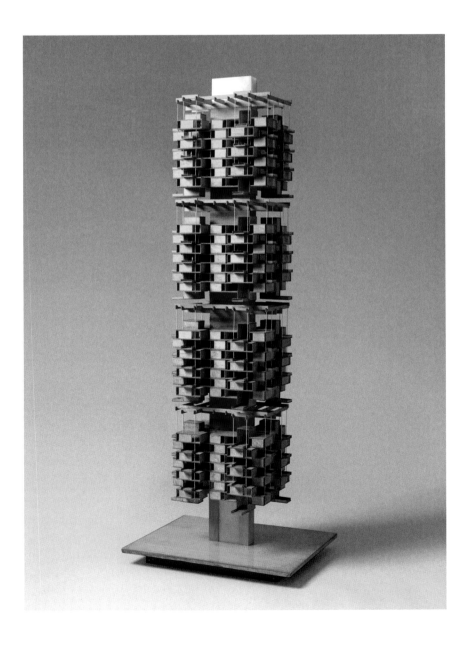

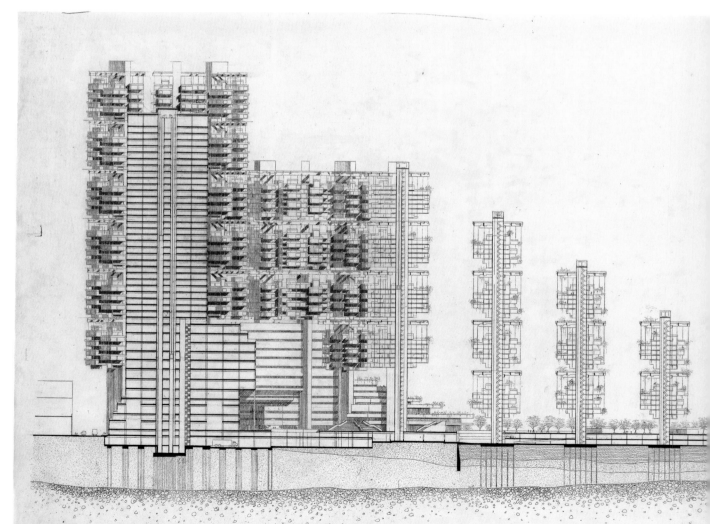

SECTION

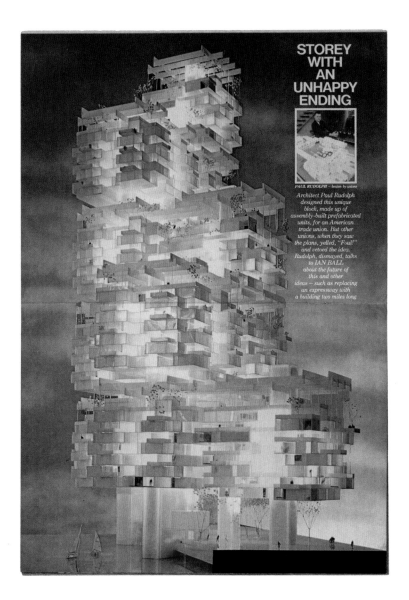

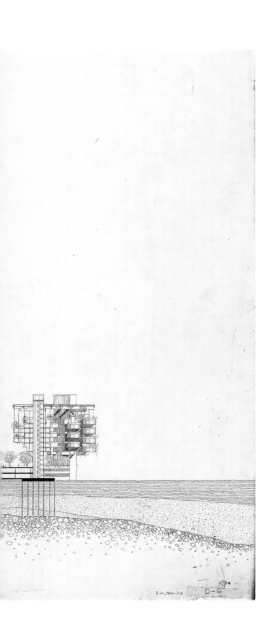

Fig. 42 Section drawing of the Graphic Arts Center project
 (unbuilt), ca. 1967, showing an arrangement of
 mixed-use towers
Fig. 43 Spread from "Storey with an Unhappy Ending,"
 The Daily Telegraph Magazine, December 13, 1968,
 depicting an illuminated model of the Graphic Arts
 Center and (inset) Rudolph with a site model for the
 Fort Lincoln housing project (both unbuilt)

Timothy Rohan eloquently describes as an "expressive cascade of irregular towers reaching out like a gesturing arm toward the river [to create a] craggy, crystalline peninsula," never left the drafting board, ironically, due to objections by building-trade unions whose members feared that the industrialized production methods would be too efficient and take valuable work away from them. As Rohan points out, had it been built, the Graphic Arts Center would have provided "spacious, inexpensive apartments with plentiful outdoor space, a precious commodity in the dense city."[90]

Rudolph's Lower Manhattan Expressway (LOMEX) project (1967, figs. 44–47), also known as the City Corridor, was an even larger and much more controversial megastructure proposal. Commissioned by the Ford Foundation in response to Robert Moses's ill-fated Lower Manhattan Expressway project, which had been defeated by activist Jane Jacobs and other civic campaigners, Rudolph's study concluded, "I don't think we need an expressway at all.… It should be a building two miles long."[91] Resembling a concrete mountain range that began at the Holland Tunnel and cut a swath across SoHo before forking over the Lower East Side to meet the Williamsburg and Manhattan Bridges, this conglomeration of elevated roadways, mass transportation, residential towers, and pedestrian walkways would have bisected—and irrevocably altered—much of Lower Manhattan. Reflecting on the proposal more than four decades later, the architecture critic Paul Goldberger found it "seductive, beautiful, exhilarating, and downright frightening," noting, "I am not sure it is possible to find anyone who regrets that this project never happened."[92] The LOMEX project was Rudolph's attempt to suggest an alternative to simply driving a highway through the city, a plan that would somehow stitch together the transportation spine with the urban fabric so that road and city essentially became one. Of course, the proposal failed to address the destruction of several communities and historic neighborhoods in its path.

Rudolph imagined his City Corridor concealing the expressway from view entirely and incorporating not only prefabricated "plugged-in" housing units and parking decks but also civic amenities such as a monorail system and public plazas that would sit on the roof of the buried roadway. The scheme reflected Rudolph's personal enthusiasm for the "compulsion of the automobile" and how this new urban "mobility, … rhythm and speed of movement" could create something architectural that was "comprehensible for the city."[93] He described the experience of driving on the F.D.R. Drive along the East River as "an architectural sequence of spaces in the scale of the motor car. You drive in, out, under, and get a kaleidoscopic, broken view in motion … and the U.N. bursts into view. It's all very exciting."[94] Rudolph's highly detailed renderings for the scheme are stunning in their boldness and scope, presenting an otherworldly, even dystopian vision. They horrified many of Rudolph's peers when they were published and conveyed the sense that he was out of touch with society's needs and values surrounding architecture, which certainly contributed to his declining reputation.

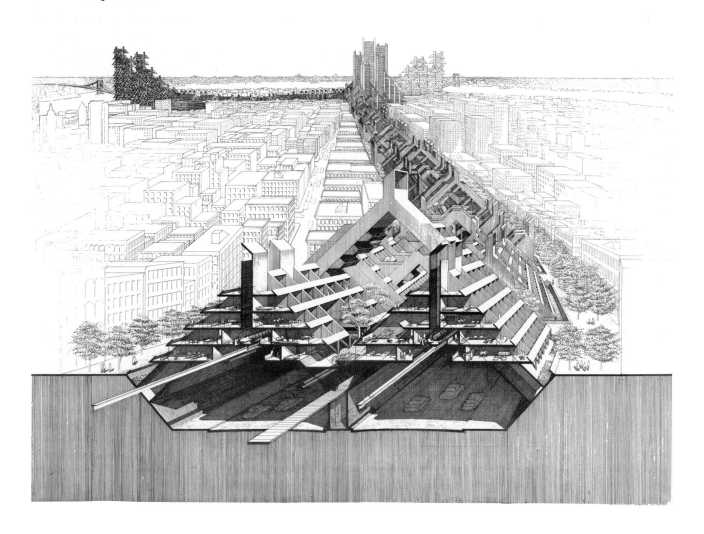

Fig. 44 Aerial perspective view and section of the Lower
Manhattan Expressway / City Corridor project
(unbuilt), showing the west-to-east path from the
Holland Tunnel toward the HUB transportation
interchange and the Williamsburg and Manhattan
Bridges, ca. 1967

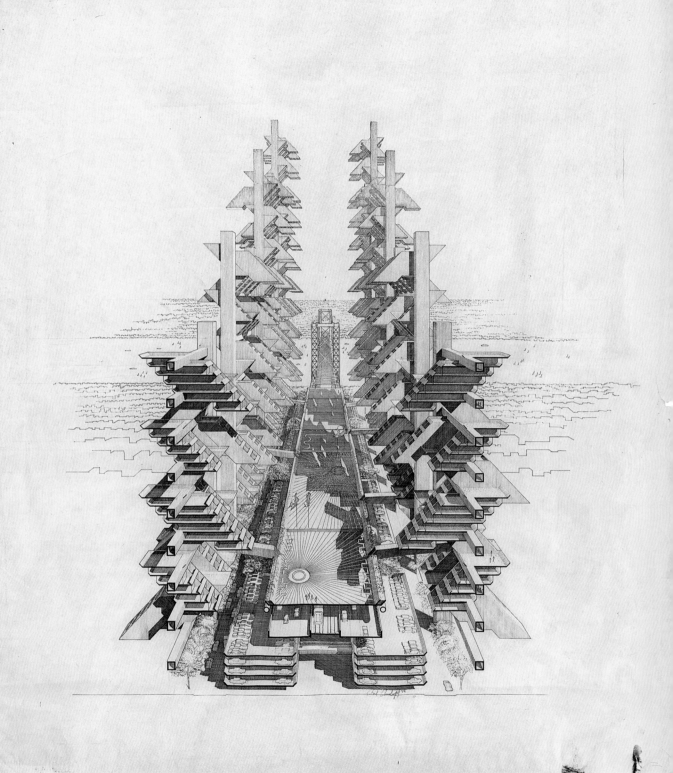

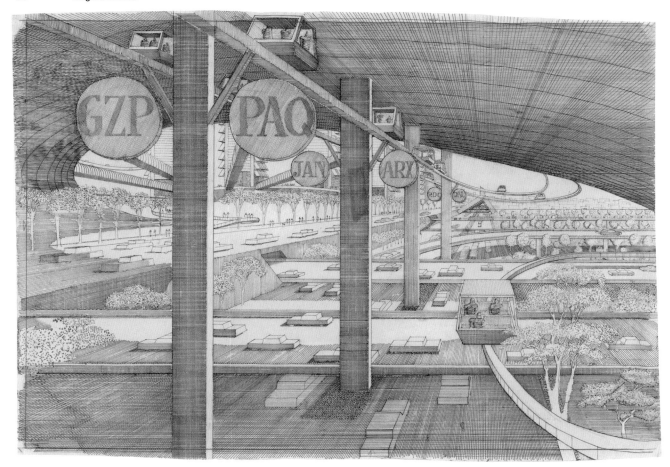

Fig. 45 Perspective section drawing of the Lower
 Manhattan Expressway / City Corridor project
 (unbuilt), showing the public plaza deck approach
 to the Williamsburg Bridge, 1972
Fig. 46 Perspective drawing of the Lower Manhattan
 Expressway / City Corridor project (unbuilt), show-
 ing the interior of the HUB transportation inter-
 change with roadways and a monorail, 1967–72

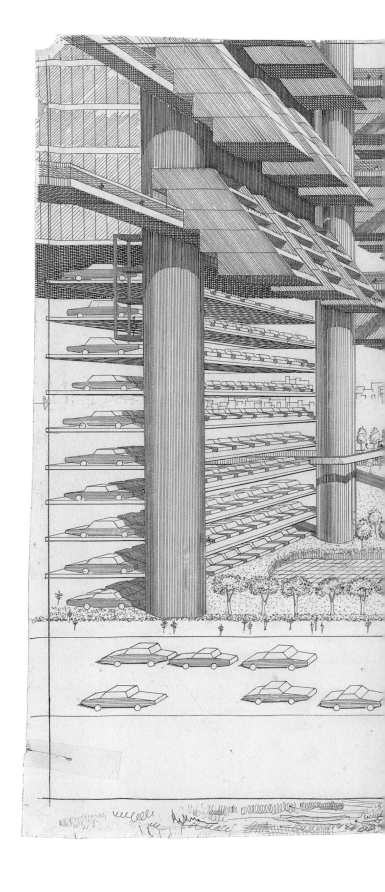

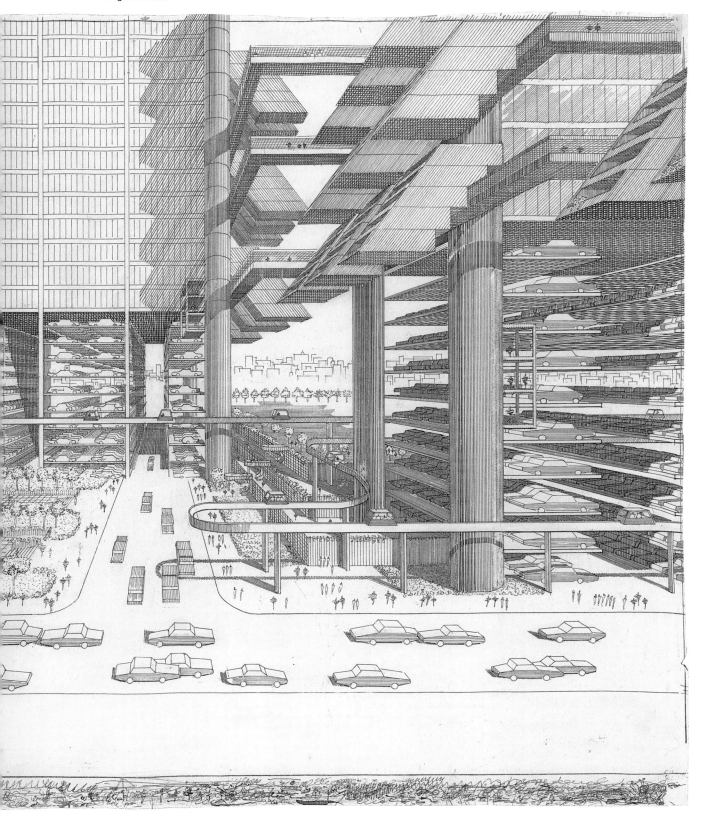

Fig. 47 Perspective drawing of the Lower Manhattan Expressway / City Corridor project (unbuilt), showing the HUB transportation interchange with mixed-use towers, parking decks, and monorail connectors, 1967–72

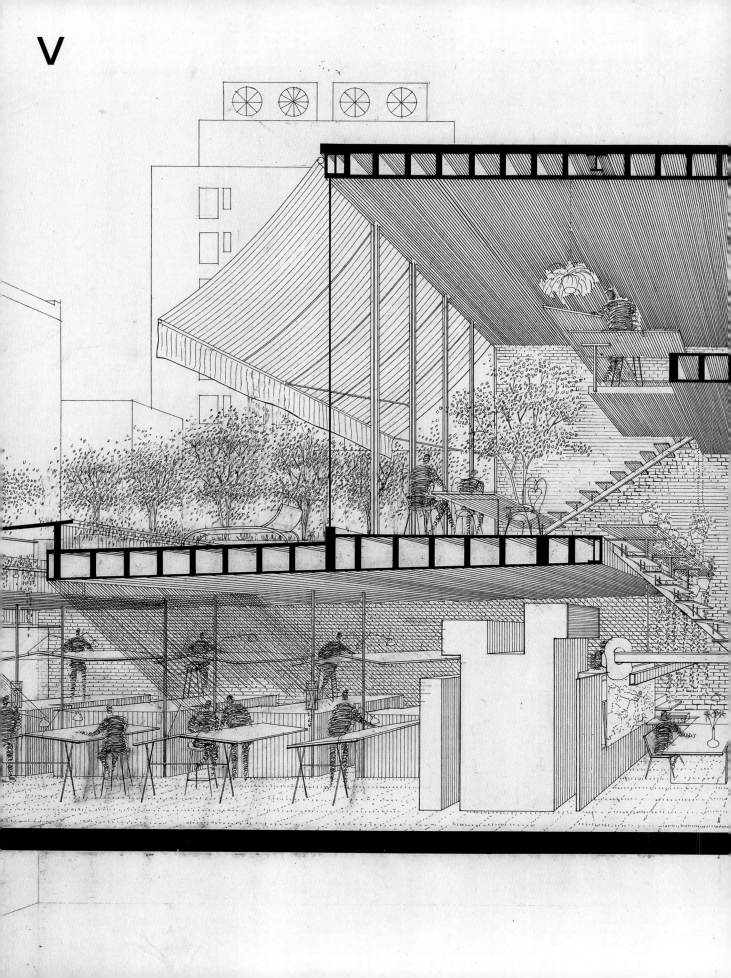

V

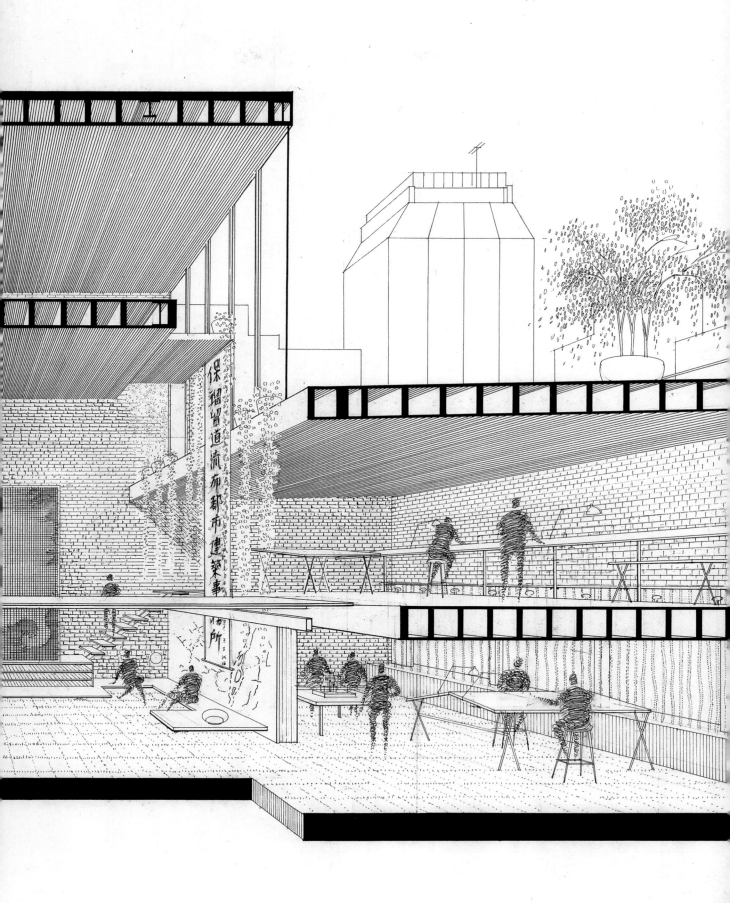

V EXPERIMENTAL INTERIORS

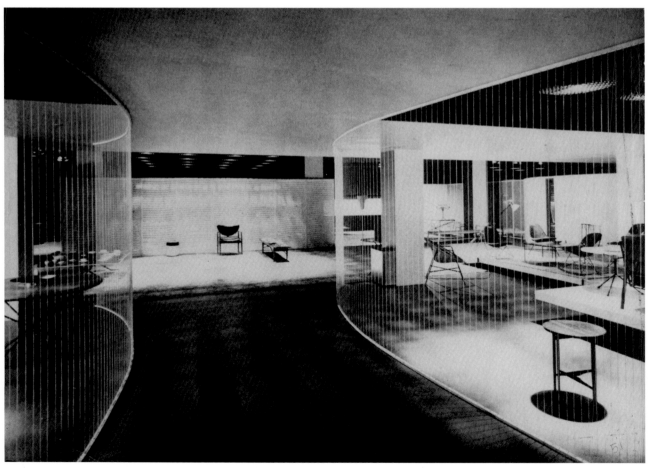

Fig. 48 Rudolph's design for the Museum of Modern Art's 1952 *Good Design* exhibition, installed at the Merchandise Mart, Chicago. Photograph by Carl Ullrich

As Rudolph's major architectural commissions slowed to a trickle, in the 1970s he turned toward interior projects and smaller-scale domestic design commissions that offered an opportunity to embrace anew the sense of pure experimentation that had suffused his best Florida houses. From those early houses to his exhibition designs for MoMA to his civic and institutional projects, Rudolph had always demonstrated a talent for manipulating light and shadow within complex architectural volumes and for scenographic "stagecraft"[95] in his configuration of space. Indeed, he conceptualized movement through interiors as a dramatic unfolding: "We need sequences of space which arouse one's curiosity, give a sense of anticipation, which beckon and impel us to rush forward and find that releasing space which dominates, which climaxes and acts as a magnet and gives direction."[96]

Rudolph enlivened his interior spaces by exploiting the interplay of light, texture, and shadow that he could achieve with unconventional materials such as plastic, metals, and mirrored surfaces. Designer George Nelson described Rudolph's concept for the 1952 *Good Design* exhibition (fig. 48) as "an extraordinarily sensitive and imaginative solution [that] revealed an unexpected flair for the dramatic. If one considers the materials used, the show is seen to consist of almost nothing: plastic cord, sprayed Cocoon, eggcrate light baffles and other devices of extreme transparency or fragility."[97] In 1961, in a commission from the Ford Foundation (several years before their invitation to work on the LOMEX project), Rudolph developed a design concept for an "Ideal Theater," in which he combined film with live stage action, incorporating both front and rear projections, as well as a screen made from translucent vertical louvers that actors could pass through. Ten years later, he integrated projections into his design for the Elman Residence (1971) in New York, where he used Plexiglas sheets at angles to project colored light into adjacent spaces.[98]

When Rudolph left Yale in 1965 to establish an architectural office in New York, he leased and renovated the top floor of a six-story building on West 58th Street near the Plaza Hotel, transforming the loft into a three-level penthouse (figs. 49, 50). The office was centered on a triple-height atrium that was dominated by the towering, wall-mounted site model for the unrealized Stafford Harbor project. Surrounding this volume was a dizzying array of floating steps, suspended catwalks, cascading plants, and employees working at drafting tables that had been mounted on top of flat file chests to create a space-saving mezzanine. One visitor described the space as "confusing, disconcerting … and vertigo-producing."[99] Although the office was short-lived, for a few glorious years it served as a showcase for the ethos of Rudolph's practice where he conducted experiments with architectural space that would define his New York interiors during the next decade.

Rudolph described his Hirsch House (1966–67, figs. 51, 52) as "a world of its own, inward looking and secretive … created in a relatively small volume of space in the middle of New York City."[100] This extensive conversion of a nineteenth-century carriage house on East 63rd Street, one of the few modernist townhouses built in New York after World War II, created what critic Paul Goldberger described as a "stunning interplay of interior levels hidden behind a dark glass façade of utter dignity."[101] Behind this stark facade of intersecting steel and glass elements, resembling a De Stijl composition, a long, "shadowy tunnel" led to "the surprise of soaring sunlit space."[102] At either end of the generous twenty-seven-foot-high living room were mezzanine and balcony levels reached by precarious walkways and a floating staircase lined with handrails of horizontal Lucite tubes that seemed to dissolve into the wall.[103] For furniture designs and other surface treatments, Rudolph showed an interest in plastics and industrial or found objects that he would develop further in the interior of his own house at 23 Beekman Place. Among his signature designs for the space were a large dining table composed of a hefty slab of Lucite resting on two thinner Lucite supports; a coffee table made from a nickel-plated section of subway grating; and, in the bathroom, "walls covered in silver Mylar, sprinkled at random with mirrored circles."[104] In 1974 the fashion designer Halston bought the house and brought Rudolph back to do a restrained renovation. As a client, he remarked, "At first you want to change everything when you move into a house like this. But the

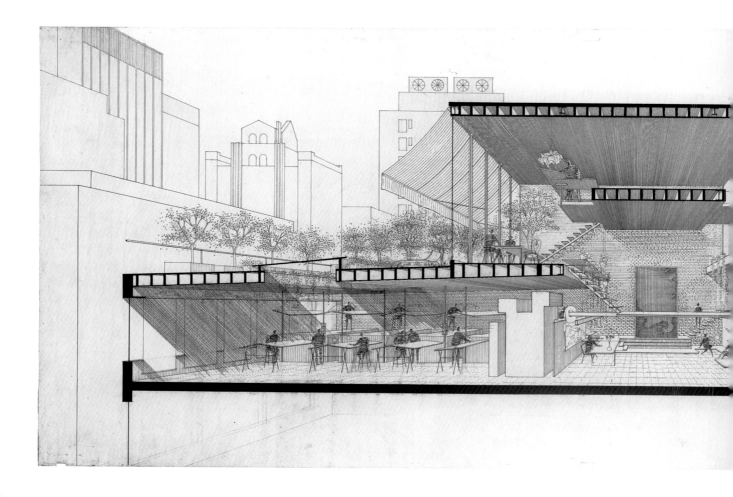

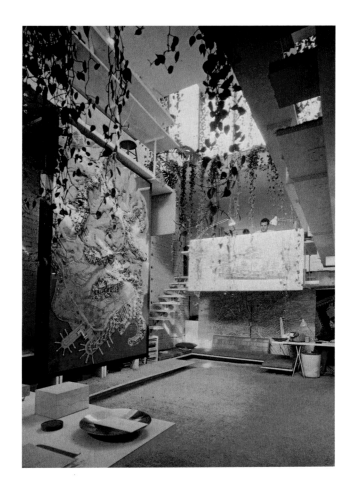

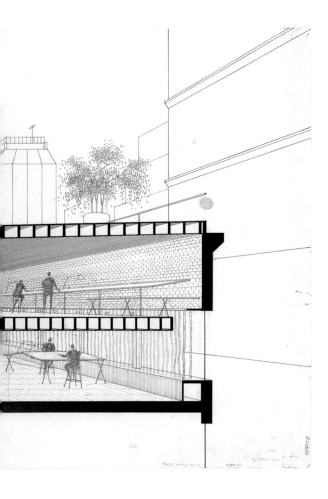

Fig. 49 Perspective section drawing of Rudolph's
 architectural office (demolished) on West 58th
 Street, New York, 1964
Fig. 50 Rudolph's New York office interior (demolished),
 showing the triple-height entrance lobby and
 his wall model for the Stafford Harbor project,
 in 1969. Photograph by Louis Reens

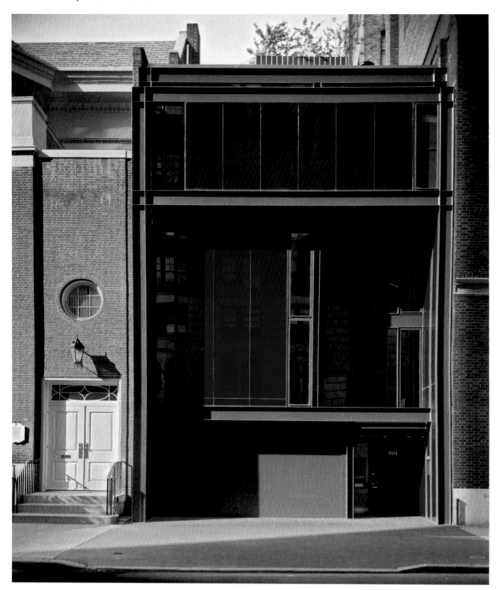

Fig. 51 The Hirsch House, East 63rd Street, New York,
 in 1969. Photograph by Ezra Stoller for *House
 and Garden*
Fig. 52 The interior of the Hirsch House, East 63rd Street,
 New York, in 1969; the coffee table at left was
 made from subway grating. Photograph by Ezra
 Stoller for *House and Garden*

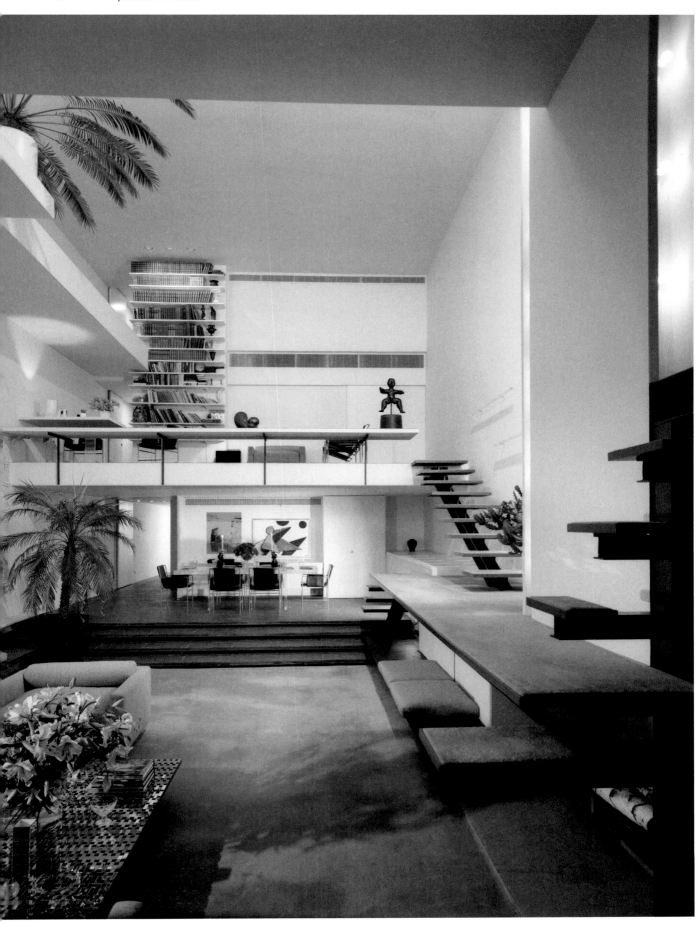

house is such a work of art you end up giving in to it."[105] Refreshed by its new occupant, the house became the venue for Studio 54 after-parties and the so-called Halston Happenings, attended by the likes of Andy Warhol, Liza Minnelli, Bianca Jagger, and other fashion celebrities and pop-culture luminaries.

Rudolph's home at 23 Beekman Place can be considered one of his most impactful statements on interior design. For more than three decades, from the mid-1960s until his death in 1997, he used his home as a laboratory for his ideas, creating a succession of changing environments that made the place feel like a modern, very New York, version of Sir John Soane's Museum in London, the home of the restlessly experimental Regency architect and collector.

During the late-1960s incarnation of Beekman Place, a stark white contour model of the Stafford Harbor project hung on the living-room wall like a shallow sculptural relief, as if to echo the West 58th Street office lobby. In the kitchen, every vertical surface was plastered with fragments of a discarded Gulf Oil billboard canvas, the offset and disjointed lettering creating the effect of a supergraphics installation (fig. 53)—not unlike the mural that Rudolph had commissioned from Norman Ives for the Yale Art and Architecture Building. In the bedroom, above the bed and facing a floor-to-ceiling mirror, hung a huge image of a hairy-chested male model surrounded by fawning female admirers (another found commercial object) from what seems to have been an advertising campaign for men's deodorant (fig. 54).

Incrementally, during the late 1960s and into the 1970s, Rudolph transformed the interiors at Beekman Place by employing a heady combination of materials, including Lucite, Plexiglas, and mirrors, in his design interventions and custom-built furniture (fig. 55). The cumulative effect of all the shiny surfaces and transparent, glassy materials was "like living in a milk bottle," as Rudolph once joked.[106] Dramatic illumination was provided by "light curtains," lengths of string lights set against mirrored walls on all sides that seemed to extend the rooms to infinity. Lit from underneath, built-in plywood platforms cushioned with foam and carpet appeared to hover above the floor. Windows were hung with drapes made of plastic discs or amber beads strung onto invisible nylon fishing lines, while circular curtains composed of reflective plastic strips divided interior spaces.

After purchasing the entire building in 1977, Rudolph started an even more ambitious program of renovations and extensions, constructing a four-story concrete-and-steel penthouse that jutted out with a dramatic cantilever over the street below (figs. 56, 57). From the sidewalk it looked like a geometric space frame had grafted itself onto the top half of the elegant limestone building. Inside, Rudolph created a soaring triple-height central living room space lined with sheets of Plexiglas, chrome, and silver Mylar-covered steel (fig. 58).

Thanks to a complicated arrangement of interleaved half-levels and quarter-levels, "disorientation was part of the spatial intrigue [and] interior views unfolded up and across the highly porous, forestlike plateaus."[107] In one notorious example of Rudolph's eccentric configuration of the vertical space, a jetted bathtub in the main bathroom with a transparent Plexiglas bottom formed the ceiling of the guest-apartment bedroom and kitchen directly below.[108] He managed to pack many more floors into the building than is apparent from the outside, as he had done at the Yale Art and Architecture Building; the central atrium is likewise a nod to that precursor's drafting room.[109]

For his custom-made furniture, Rudolph often selected off-the-shelf industrial materials and components and applied them in novel ways: for example, balls of jersey stretch fabric pulled through holes in Plexiglas sheets to create cushioned seating; bedsprings converted to seat backs for swivel chairs; and a large plastic cylinder ("an antique"[110]) found on the street and repurposed as a dining-table base. To make his famous Rolling Chair, he assembled rigid Lucite panels using a Danish chromed-metal modular shelving system[111] and attached industrial-spec caster wheels (see fig. 63). Rudolph's integration of found objects in the Beekman Place design likewise echoes his practice in previous projects—think of the Yale Art and Architecture Building, whose interior incorporates plaster casts and nautilus shells. In one of Rudolph's earliest residential designs, the Miller Guest House (1949) in Florida, he had suspended a piece of found driftwood over the water with a steel armature, like

Fig. 53 The kitchen in the Beekman Place apartment as it looked in 1967, featuring supergraphics installed on the cabinets and walls. Photograph by Ezra Stoller for *House Beautiful*

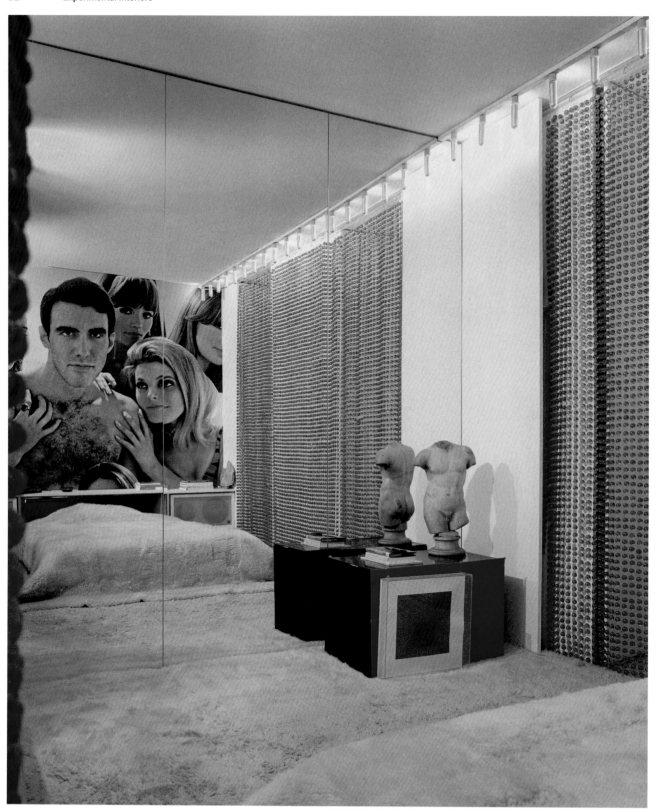

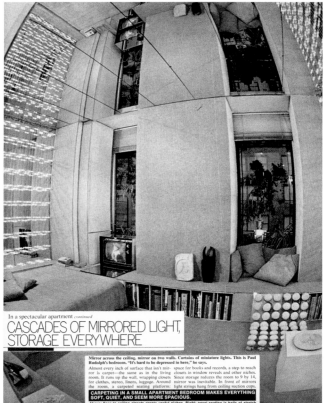

In a spectacular apartment *continued*

CASCADES OF MIRRORED LIGHT, STORAGE EVERYWHERE

Mirror across the ceiling, mirror on two walls. Curtains of miniature lights. This is Paul Rudolph's bedroom. "It's hard to be depressed in here," he says.

Almost every inch of surface that isn't mir-ror is carpet—the same as in the living room. It runs up the wall, wrapping closets for clothes, stereo, linens, luggage. Around the room, a carpeted seating platform: space for books and records, a step to reach closets in window reveals and other niches. Since storage reduces the room to 9 by 14, mirror was inevitable. In front of mirrors light strings hang from ceiling suction cups.

CARPETING IN A SMALL APARTMENT BEDROOM MAKES EVERYTHING SOFT, QUIET, AND SEEM MORE SPACIOUS.

Above: floor-to-ceiling closets create useful niches. *Right:* novel seating is balls of stretch

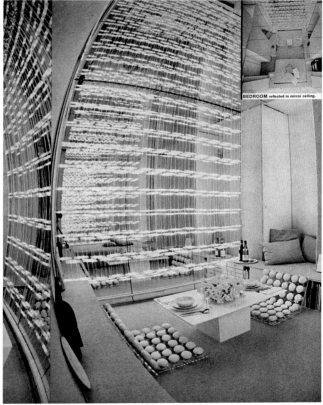

BEDROOM reflected in mirror ceiling.

Fig. 54 The bedroom in the Beekman Place apartment as it looked in 1967, featuring curtains of plastic beads and a large-scale advertising image installed over the bed, reflected in a floor-to-ceiling mirror. Photograph by Ezra Stoller for *House Beautiful*

Fig. 55 Tear sheets from "A Spectacular Apartment by Paul Rudolph ... Cascades of Mirrored Light, Storage Everywhere," *House and Garden*, October 1976

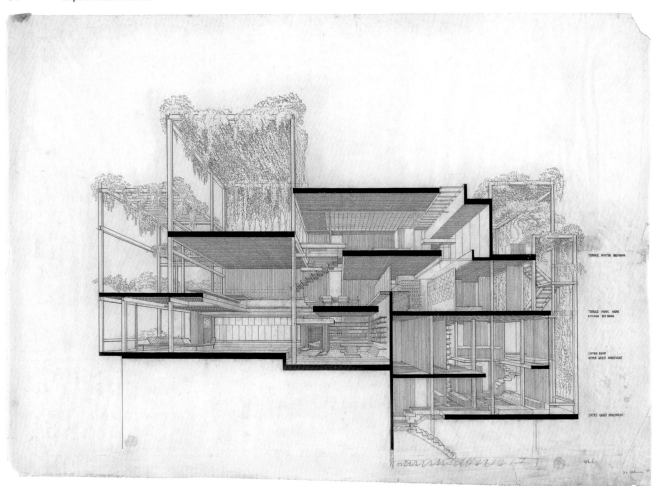

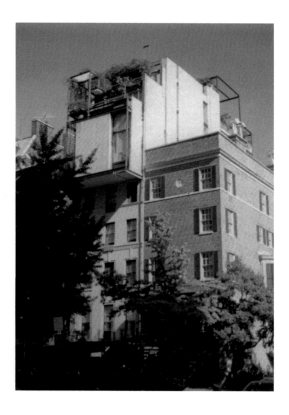

Fig. 56 Perspective section drawing showing Rudolph's penthouse conversion and expansion to create a quadruplex apartment at 23 Beekman Place, ca. 1976

Fig. 57 The exterior of 23 Beekman Place, showing the penthouse quadruplex

Fig. 58 The interior of the Beekman Place apartment, after the creation of the penthouse, showing the triple-height living-room space. Photograph by Peter Aaron

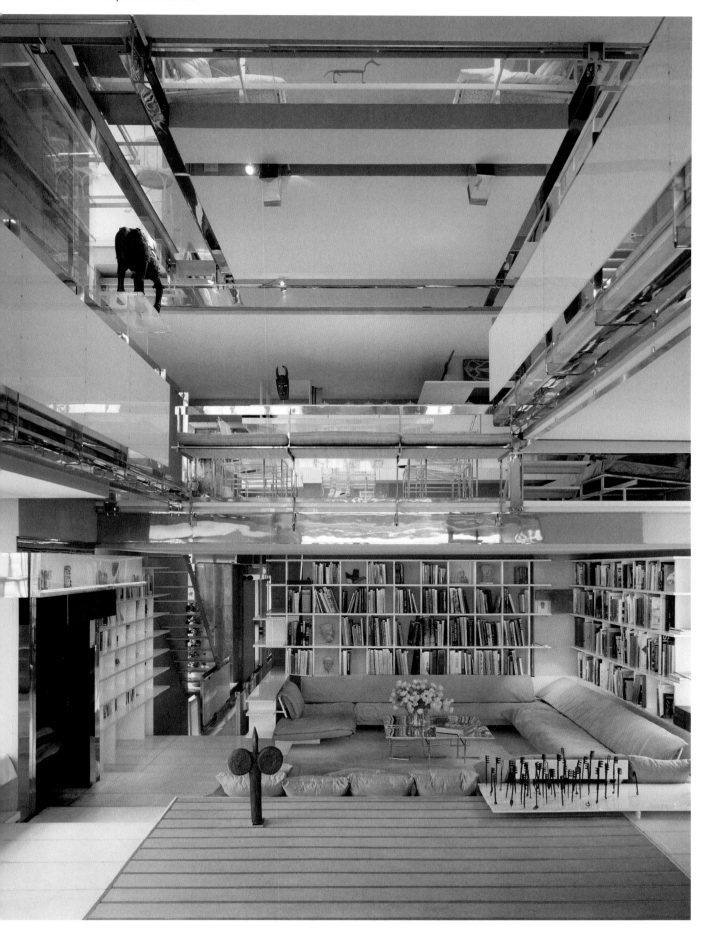

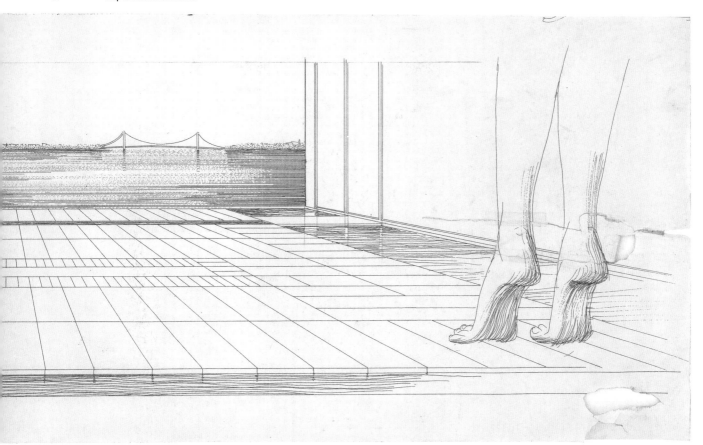

Fig. 59 Perspective drawing of the Beekman Place
 apartment, showing imaginary view toward the
 East River from the proposed terrace, ca. 1976
Fig. 60 Miller Guest House, Florida, 1949. Photograph
 by Ezra Stoller

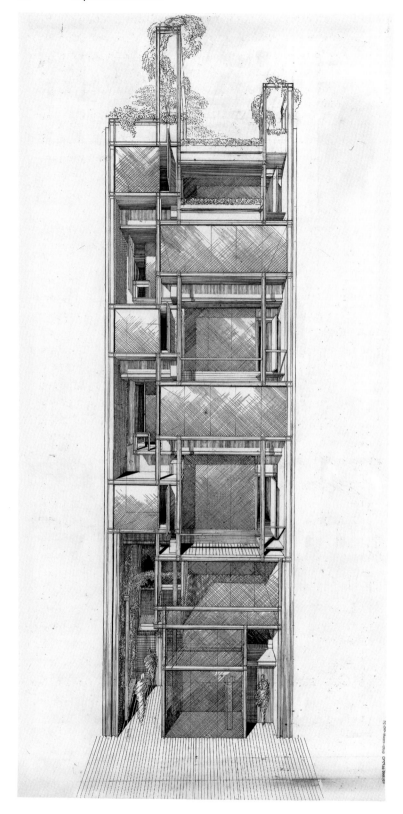

Fig. 61 Perspective drawing of the Modulightor Building,
 246 East 58th Street, New York, ca. 1989
Fig. 62 Facade study model for the Modulightor Building,
 ca. 1989

an abstract sculptural installation; a drawing of a somewhat imaginary view from Beekman Place's outdoor terrace overlooking the East River includes a similarly surreal sculptural object, framed by a cascade of hanging plants (figs. 59, 60).

Although now drastically altered on the interior, 23 Beekman Place remains one of Rudolph's boldest visions. The critic and designer Michael Sorkin described it as "one of the most amazing pieces of modern urban domestic architecture produced in this country, a structure packing more finesse and design wallop in its compact volume than many architects manage to produce over entire careers."[112]

In the late 1980s Rudolph developed a townhouse at 246 East 58th Street as a base for the lighting firm Modulightor, which he had founded with his partner, Ernst Wagner (figs. 61–63). Like 23 Beekman Place, this building became a showcase for Rudolph's ideas relating to interior design. It also now houses many of the small, often unidentified, objects—such as concrete test samples, industrial objects, and hand-painted Japanese toy robots—that Rudolph had collected and displayed in his home and that had inspired or reflected his thinking about materials, texture, and form (fig. 64).

In addition to his built interiors, Rudolph took on commissions from magazines to design purely speculative interiors, for example, a project that "envisioned two bath environments of the future" for a 1976 feature in *House and Garden* (fig. 65).[113] Like Rudolph's custom furniture, these "His and Hers" bathrooms utilized industrial off-the-shelf components and materials. Aluminum air-conditioning ducts, copper sheeting, and Plexiglas panels lend the spaces a High-Tech gloss, anticipating design directions that would become more popular during the 1980s.[114]

Interior designs and domestic projects offered a refuge for Rudolph at a difficult time for him professionally. However, they also gave him creative freedom. He treated these projects like personal laboratories, as a way of prototyping certain ideas about materiality and space without taking the risks involved in larger architectural commissions with higher stakes. These interior experiments prepared him for his imminent return to larger urban projects, as had been his long-held goal.

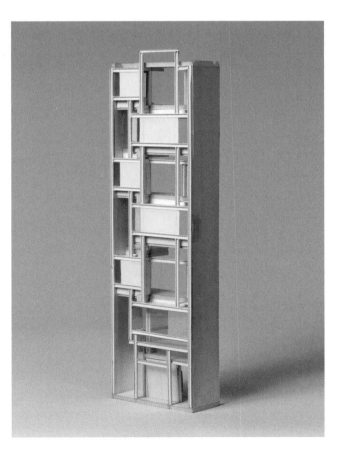

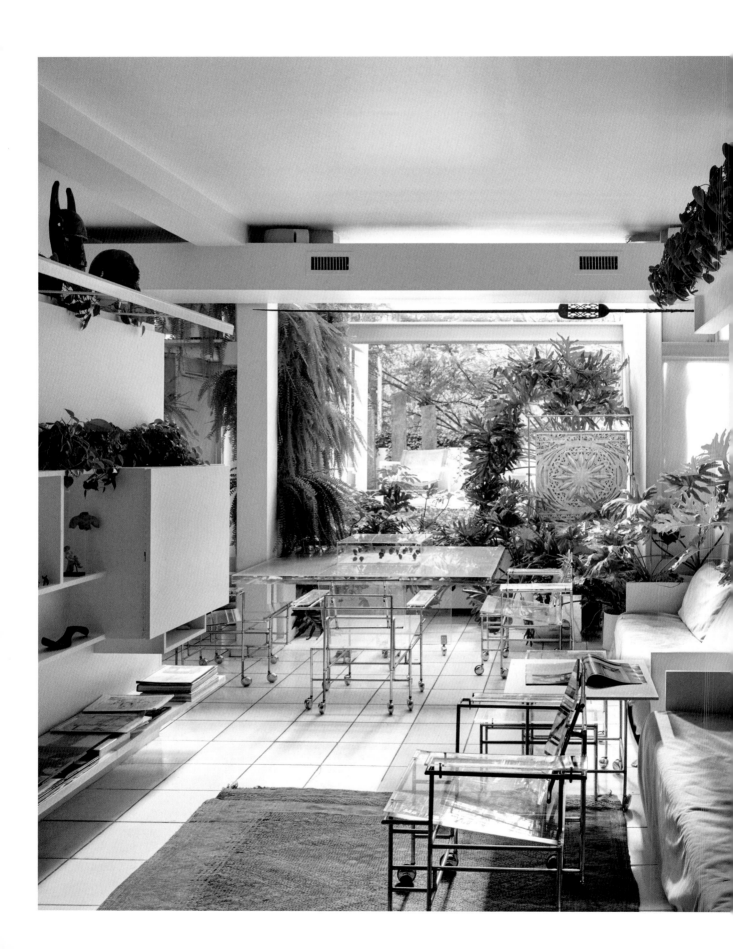

Fig. 63 The interior of the Modulightor Building in 2018.
 Photograph by Annie Schlecter for *The New York
 Times*

Fig. 64 The interior of the Modulightor Building in 2024,
 showing some of Rudolph's collection of industrial
 objects and found items, all studies of materiality
 and form. Photograph by Eileen Travell

Fig. 65 Tear sheet from "From its Swirling Source, Water
 Inspires Architect Paul Rudolph to Design Two
 Exciting and Prophetic Baths," *House and Garden*,
 February 1976

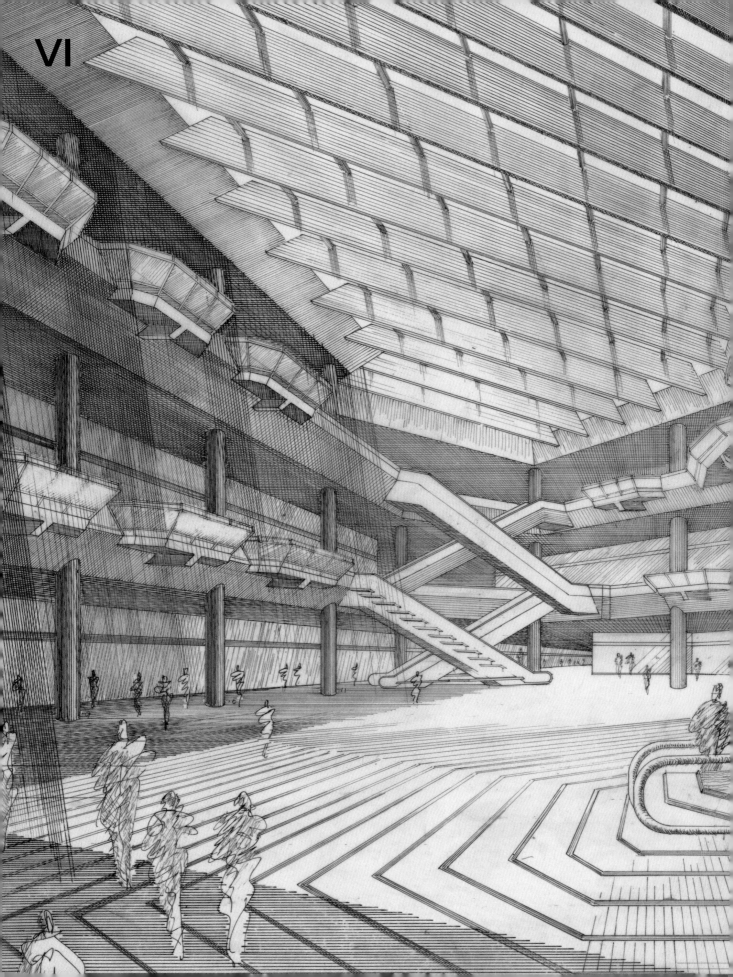

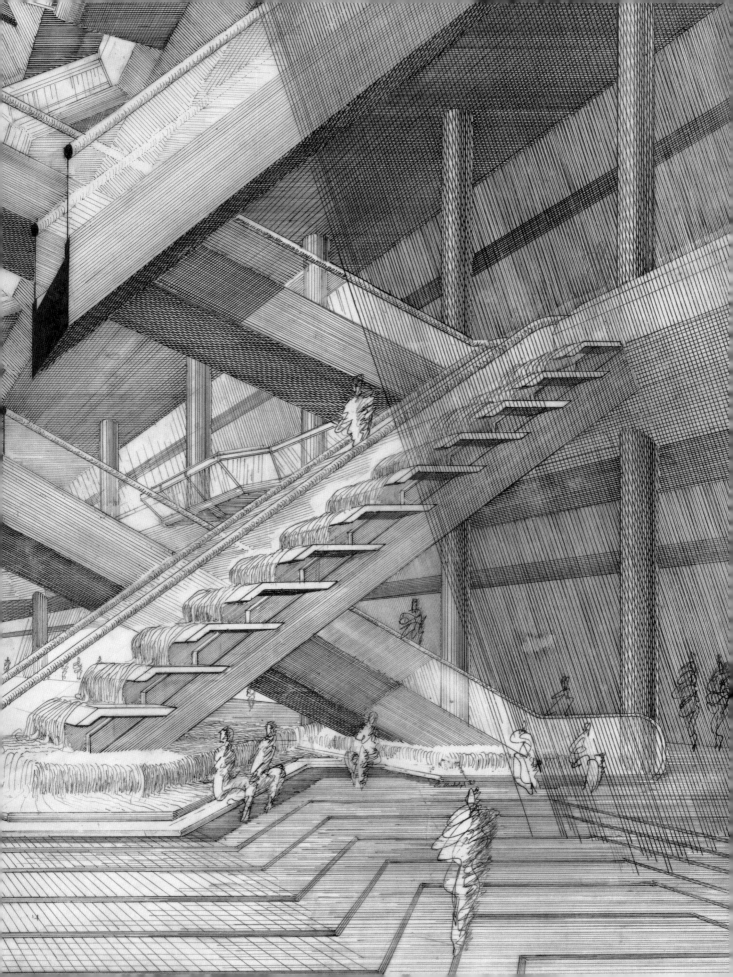

VI PROJECTS IN ASIA

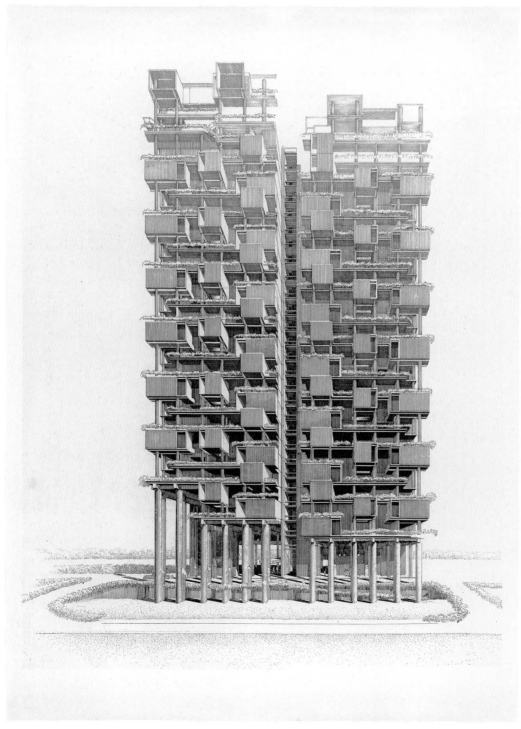

Fig. 66 Perspective rendering of the Colonnade apartment building, Singapore, 1980

During the 1980s and 1990s, Rudolph was at the vanguard of a group of architects from North America and Europe, including Norman Foster (Rudolph's former student at Yale), I. M. Pei, César Pelli, and Zaha Hadid, who won commissions for large-scale projects and skyscrapers in major Asian cities. For Rudolph, these new commissions were significant for several reasons. First of all, after a relatively fallow period in the 1970s, he was finally poised to make a professional comeback. Secondly, although the economy in Asia had its ups and downs, he prospered from the work, which allowed him to invest in his ongoing renovations at Beekman Place and to purchase the Modulightor Building. Lastly, and perhaps most crucially, the briefs for these projects presented Rudolph with opportunities to return to certain concepts from earlier in his career, which he could finally implement at an appropriate scale and with a sufficient budget, and to fulfill his long-standing desire to work on tall buildings.

Rudolph's first project during this period was the Colonnade apartment building (1980–86, fig. 66) in Singapore, where he would base himself for his work in the region. With the Colonnade project he was finally able to apply his concept of the "twentieth-century brick." The structure has compositional similarities to his Trailer Tower from almost three decades earlier, with individual modules seemingly "plugged in" to a central core. However, although at first glance the uniformly painted white units appear to be prefabricated, they were constructed from brick and concrete using conventional methods, and none of these modules were "hoisted in," as Rudolph originally conceived—a compromise comparable to the one he made for his Green Residence, which also merely gives the impression of modular assembly (see fig. 13). Aesthetically, the project succeeded in replicating the texture and surface details of Rudolph's "twentieth-century brick" proposals and conveys a sense of the impressive massing that defines his megastructure projects, such as the Graphic Arts Center.

Rudolph's other major commission in Singapore was the Concourse (1979–94, figs. 67, 68), a large, mixed-use complex of offices, residential units, and retail space that took around fifteen years to complete due to various economic crises in the region. The project had

similarities to Rudolph's original scheme for the Boston Government Service Center, with a tall tower surrounded by low-rise buildings, as well as a public plaza articulated with textured surface markings. A bravura example of Rudolph's draftsmanship, the rendering of the Concourse's lobby resonates with Rudolph's drawing of the Tuskegee Chapel interior (see fig. 32); both demonstrate a muscular handling of light and shadow, as well as a profound sense of what Rudolph would describe as the flowing architectural energy within the space.[115]

In Hong Kong, Rudolph worked on two key projects, the Sino Tower (1989, figs. 69, 70), which remains unbuilt, and the Bond Centre (1984–88, fig. 71). Also known as the Harbour Road Tower, the Sino Tower was an entry in an architectural competition for the Sino Land Company to build the tallest tower in Asia, and it is perhaps the clearest statement of Rudolph's vision for constructing skyscrapers. Its highly idiosyncratic form rejects both the functionalism of International Style modernism and the historical quotations of postmodernism, instead presenting a bold, tapering form that evokes the crystalline massing of Rudolph's earlier proposals for prefabricated modular buildings and megastructures. The Bond Centre (now known as the Lippo Centre) consists of two almost identical octagonal glass towers, similar in form to Rudolph's City Center Towers (1978) in Fort Worth, Texas. The project has probably garnered more international attention than any of his other projects in East Asia because of its prominent site in a dense downtown location by the Hong Kong harbor front and its proximity to two other important buildings from about the same time: Foster's HSBC Headquarters (1979–86) and Pei's Bank of China Tower (1985–90). Although the completed building turned out quite different from the drawing, it is interesting to note how this early scheme reveals several expressive engineering details, including external cross-bracing and diagonal sky bridges that bring to mind Charles Sheeler's famous 1927 photograph of the Ford Motor Company's River Rouge factory. Rudolph rarely strayed into the territory of the architectural High-Tech style, as prominently displayed in the exposed structural elements of Foster's HSBC building, but it is also evident in his unbuilt International Building (1990, fig. 72) for Hong Fok

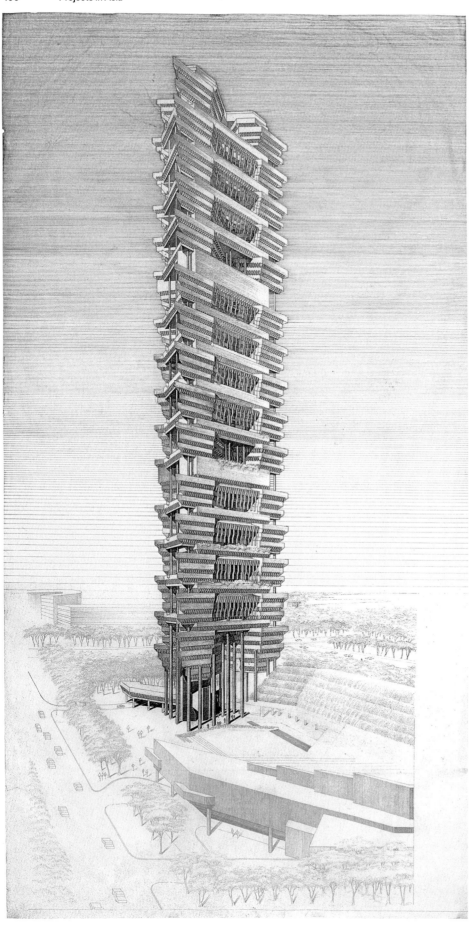

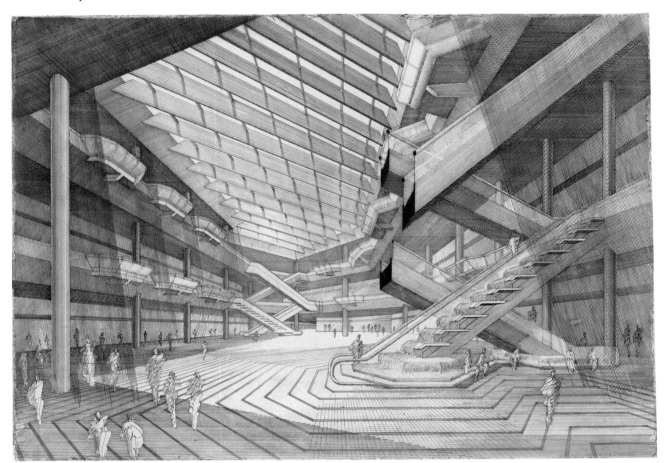

Fig. 67 Perspective drawing (early design) of the
 Concourse / Beach Road II Office Tower project,
 Singapore, 1981
Fig. 68 Perspective drawing of the lobby interior of the
 Concourse (partially demolished), Singapore, 1983,
 featuring daylit spaces and a cascading waterfall

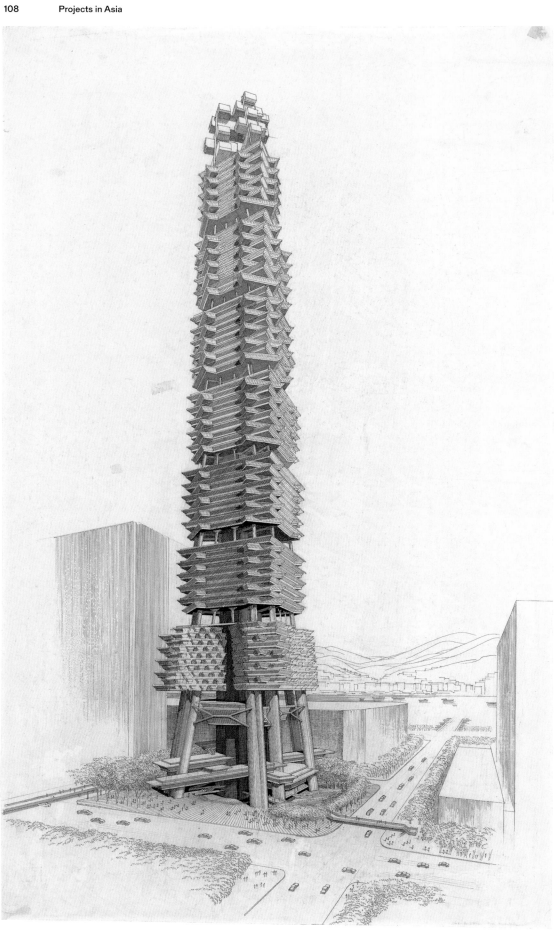

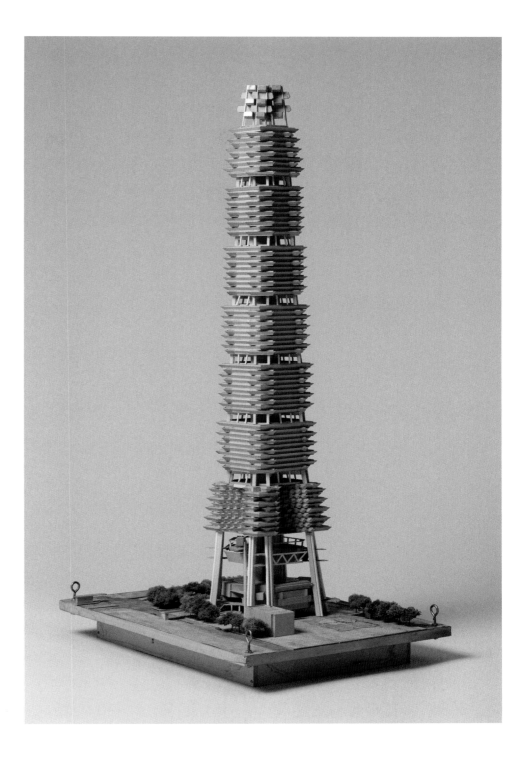

Fig. 69 Perspective drawing of the Sino Tower / Harbour
Road project (unbuilt), Hong Kong, 1989
Fig. 70 Architectural model for the proposed Sino Tower
(unbuilt), 1989

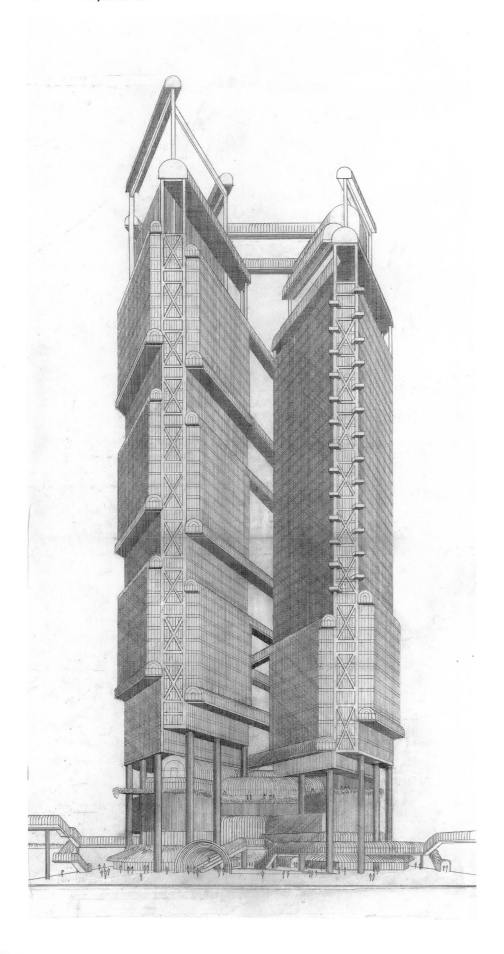

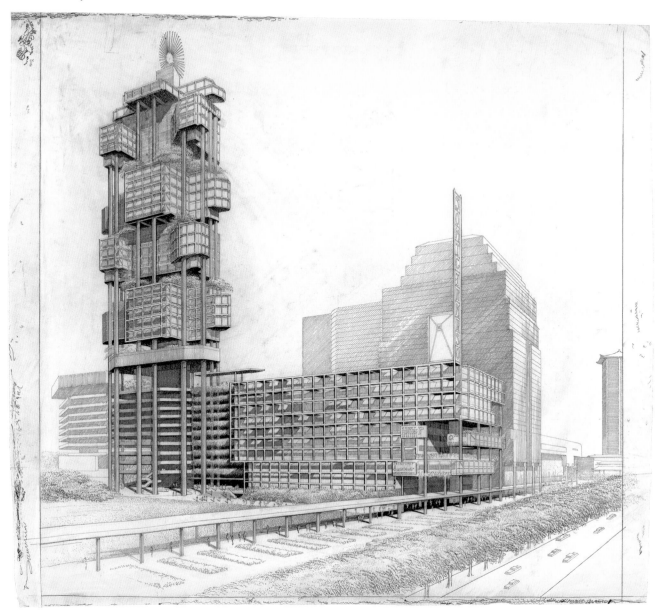

Fig. 71 Perspective drawing (early design) of the Bond
 Centre (now Lippo Centre), Hong Kong, ca.1984
Fig. 72 Perspective drawing of the International Building
 for Hong Fok Corporation (unbuilt), Singapore,
 1990

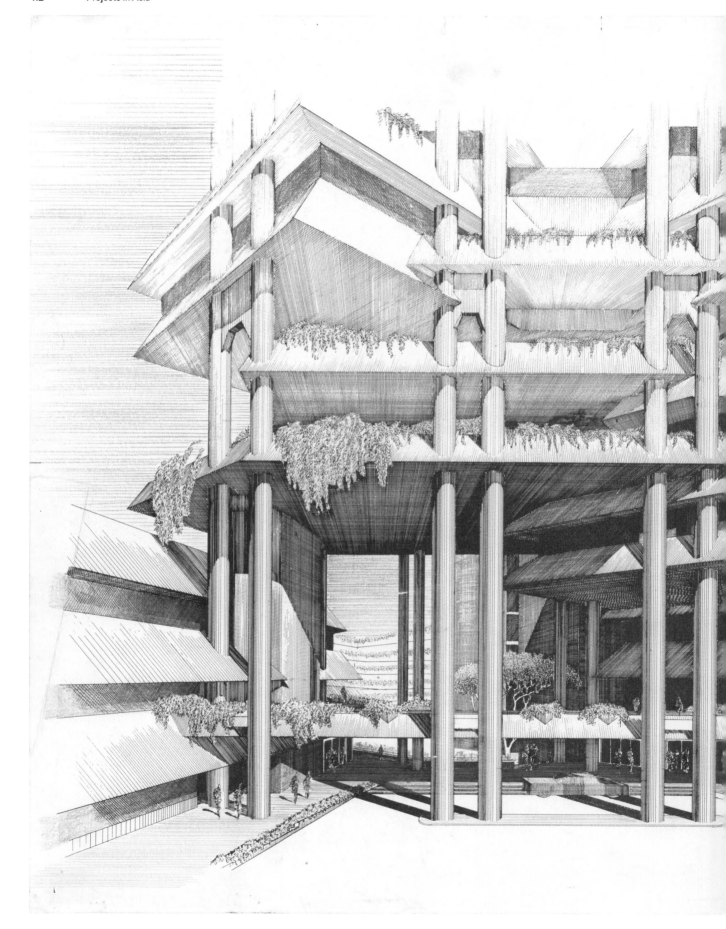

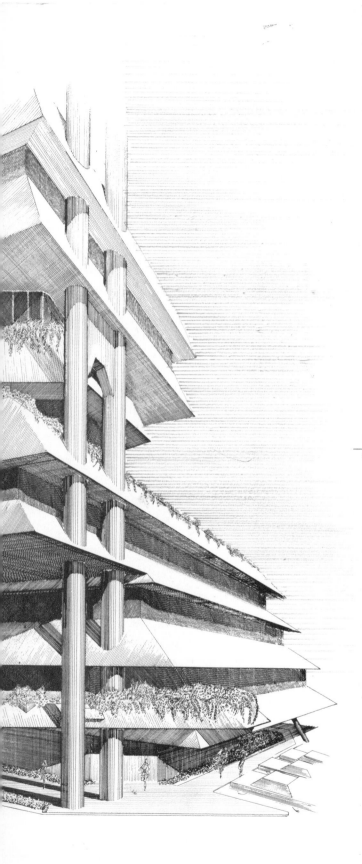

Corporation in Singapore, a tower whose forms additionally seem to suggest the massing of a megastructure project.

Rudolph was inspired by Hong Kong's urban density and complexity, especially its many miles of elevated pedestrian walkways that stitched together the city's buildings and street levels. No doubt this cityscape reminded him of his similar ideas for the Lower Manhattan Expressway / City Corridor project. He designed pedestrian sky bridges that could connect the Bond Centre to surrounding buildings and the existing system of elevated walkways, creating links that were not only functional and efficient but also "a means of enhancing the three-dimensional, layered feel of the city."[116]

Rudolph worked on several projects in Indonesia during this period, the most significant of which was the Wisma Dharmala Headquarters Building in Jakarta, later renamed the Intiland Tower (1982–90, fig. 73), a new headquarters for a real estate and financial trading group. In researching a local architectural vernacular that could be applied to a building of this scale, he became fascinated with traditional Indonesian gabled roofs and their exaggerated overhangs, and he drew upon this form to create a series of stacked, cantilevered overhangs suspended on paired concrete columns. The deep, angled projections not only cool the building naturally but also enhance the structure's sculptural qualities, which are particularly noticeable in the atrium lobby and twelve-story sheltered open-air courtyard.

Rudolph dearly wanted his Asia projects to provide the right catalyst to finally restore his reputation and even hoped that he could stage a late-career comeback, as Frank Lloyd Wright had done in his seventies.[117] But it was not to be. Although these late works were the focus of exhibitions in New York and Chicago,[118] the mainstream architectural press did not pay serious attention, and he was dismissed for being still out of sync with the times, rehashing previous designs in new contexts, and seeming oblivious to the rising tide of postmodernism.

Fig. 73 Perspective drawing of the Wisma Dharmala Headquarters Building (now Intiland Tower), Jakarta, Indonesia, ca. 1982

LEGACY

—Drawn for the RECORD by Alan Dunn

"But Paul Rudolph would have to be 'explained'!"

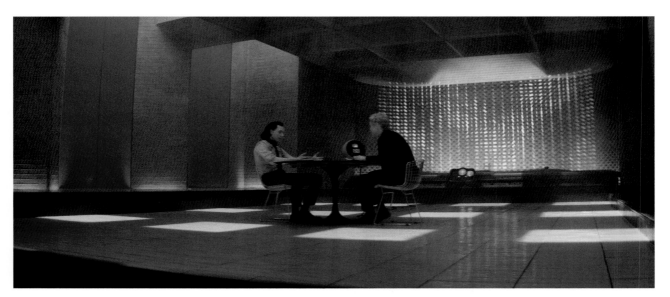

Fig. 74 Cartoon by Alan Dunn for *Architectural Record*,
 "But Paul Rudolph Would Have to Be 'Explained'!"
 ca.1970
Fig. 75 Production still from Marvel Studios' *Loki*, season 1,
 episode 4, 2021

In 1997, the year that Rudolph died, the architectural historian Kurt Forster remarked, "During the 1960s and 1970s no publication on American architecture could do without Rudolph; today few remember him, and even fewer regard his buildings with anything but historical interest.... The contrast between being famous and being forgotten is more stark than with any other figure who comes to mind."[119] Writing a few years earlier, Michael Sorkin acknowledged Rudolph's rise and fall but struck a slightly more positive note about his legacy: "In 1963, Paul Rudolph bestrode American architecture, a brush-cut colossus.... By the early 70s, it was over. Rudolph was still building, but it wasn't like before, and it hasn't been that way since.... But one thing has not changed: Rudolph is still the most brilliant designer of his generation."[120] These two descriptions of Rudolph's career arc not only sum up the professional misfortunes that faced the once lionized architect but also vividly testify to his dogged determination and stark independence. Throughout his life, Rudolph avoided the conformist voices of architectural consensus and ignored popular critical opinion while carving a path that was often thorny to navigate (fig. 74).

Rudolph's donation of his architectural archives to the Library of Congress and the renovation of the Yale Art and Architecture Building, completed a decade after his death, have helped build momentum for the gradual, long-overdue reappraisal and rehabilitation of his career in recent years. Rudolph once described his work as ranging "from Christmas lights to megastructures,"[121] referring to projects as disparate as his mirrored light curtains at 23 Beekman Place and his City Corridor proposal for the Lower Manhattan Expressway. This refusal to be categorized and tagged makes him a challenging architect to summarize, but it is equally the quality that makes him a fascinating topic for research—and it is what drives new audiences to discover, or rediscover, his work every day. The destruction of many of his buildings—for example, the loss of several houses and a high school in Sarasota, as well as the full or partial demolition of major projects such as the Burroughs-Wellcome Company Headquarters, the Orange County Government Center, and the Buffalo Waterfront—all within the last two decades has provoked a renewed focus on saving the buildings that are currently under threat. His legacy also lives on through the images of his extraordinary interiors, which are often cited by production designers in film and TV as key sources of inspiration for the worlds that they create (fig. 75). As evidence of how Rudolph's legacy was starting to take shape toward the end of his life, his *New York Times* obituary observed, "In recent years, American architecture students ... have rediscovered Mr. Rudolph as a model of rare integrity.... [At a lecture] he drew a standing-room-only crowd composed mostly of the young and held the audience spellbound, as if he were a visitor from a long-vanished golden age."[122] Considered together, Rudolph's intricate, visionary drawings and dramatic completed buildings represent a singular voice within the crowded, variable terrain of architectural late modernism, one that will continue to prove spellbinding and confounding for many years to come.

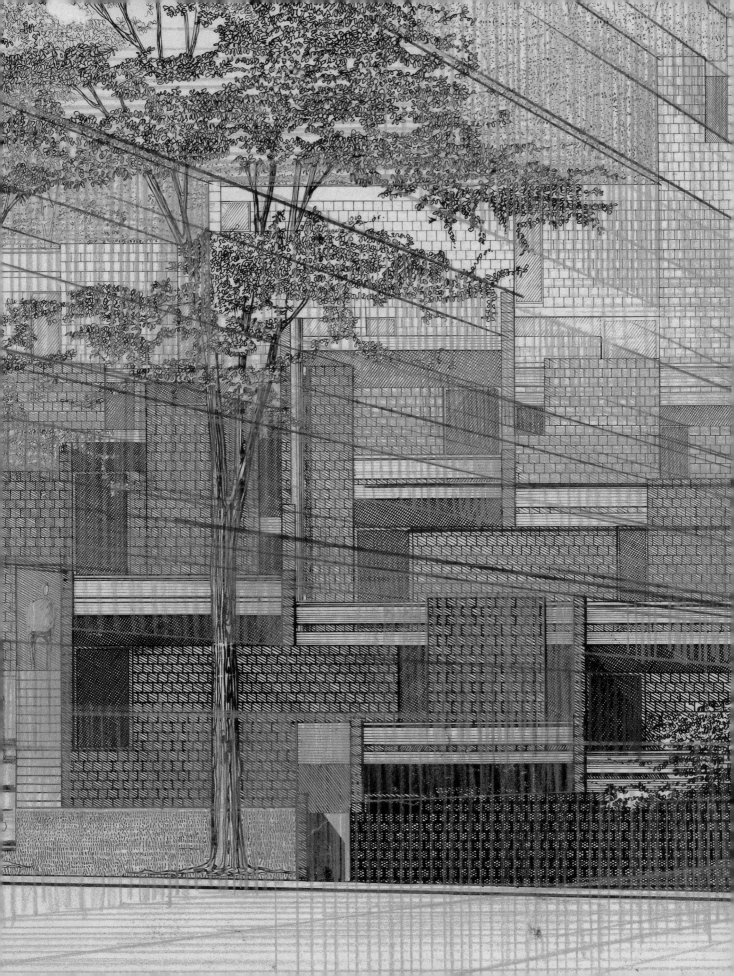

DRAWINGS AND MODELS

Unless otherwise noted, all works are in the Paul Marvin Rudolph Archive, Prints and Photographs Division, Library of Congress, Washington, DC.

With one exception (fig. 24), all works are by Paul Rudolph (American, 1918–1997).

Fig. 5 Elevation drawing for Married Student Housing at Yale University, New Haven, Connecticut, ca. 1960. Photomechanical print, colored pencil, and sepia on paper, 19⅜ × 60¼ in. (49 × 153 cm)

Fig. 6 Rendering of the Knott Residence (unbuilt), Yankeetown, Florida, ca. 1951. Photomechanical print, 6¾ × 11⅞ in. (17 × 30 cm)

Fig. 8 Aerial perspective drawing of the Healy Guest House (Cocoon House), Sarasota, Florida, 1948–50. Ink and tonal film overlay over graphite underdrawing on illustration board, 24¾ × 19⅞ in. (63 × 50.5 cm)

Fig. 12 Isometric drawing of the Bass Residence, Fort Worth, Texas, 1970. Ink on paper, 44⅛ × 42⅜ in. (112 × 107.5 cm)

Fig. 13 Perspective drawing studies for the Green Residence, Cherry Hill, Pennsylvania, 1989. Ink on tracing paper, 14⅝ × 64¾ in. (37.1 × 164.5 cm). The Museum of Modern Art, New York, Gift of the architect (96.1989)

Fig. 15 Aerial perspective drawing of the Stafford Harbor residential project (unbuilt), Virginia, 1966. Xerox on vellum, 27½ × 39 in. (70 × 99.2 cm)

Fig. 17 Aerial perspective drawing of the Tracey Towers housing project, Bronx, New York, 1967. Graphite on tracing paper, 18½ × 34⅝ in. (47 × 88 cm)

Fig. 20 Perspective drawing of the Art and Architecture Building, Yale University, New Haven, Connecticut, 1958. Ink on board, 30 × 40 in. (76.2 × 101.6 cm). The Museum of Modern Art, New York, Gift of the architect (405.1985)

Fig. 21 Perspective section drawing of the Art and Architecture Building, Yale University, New Haven, Connecticut, 1958. Pen and ink, graphite, and plastic film with halftone pattern, on illustration board, 36⅞ × 53⅝ × 2 in. (93.6 × 136.2 × 5.1 cm). School of Architecture, Yale University, Manuscripts and Archives, Yale University Library

Fig. 24 Helmut Jacoby (German, 1926–2005). Presentation rendering for Rudolph's proposed tower (unbuilt) for the Boston Government Service Center, 1963. Photomechanical print on paper with linen backing, 48⅞ × 33⅞ in. (124 × 86 cm)

Fig. 26 Aerial perspective drawing of the Southeastern Massachusetts Technological Institute (SMTI, now UMass, Dartmouth), North Dartmouth, Massachusetts, 1963. Ink and graphite, tonal film overlay on board, 33⅞ × 58⅝ in. (86 × 149 cm)

Fig. 28 Perspective section drawing of the Burroughs-Wellcome Company Headquarters (demolished), North Carolina, 1969–72. Ink on vellum, 35⅞ × 86¼ in. (91 × 219 cm)

Fig. 29 Interior perspective drawing of the Burroughs-Wellcome Company Headquarters (demolished), North Carolina, 1969–72. Diazo and sepia print, 36⅝ × 59 in. (93 × 150 cm)

Fig. 31 Aerial perspective section drawing of East Pakistan (now Bangladesh) Agricultural University, Mymensingh, ca. 1969. Ink on tracing paper, 52¾ × 33¾ in. (134 × 85.6 cm)

Fig. 32 Interior perspective drawing of Tuskegee Institute Chapel (now Tuskegee University), Tuskegee, Alabama, ca. 1960. Colored pencil over sepia print, 37⅜ × 29⅜ in. (95 × 74.6 cm)

Fig. 35 Isometric site plan study for the Fort Lincoln housing project (unbuilt), Washington, DC, 1966–68. Graphite on tracing paper, 22 × 37 in. (56 × 94 cm)

Fig. 36 Perspective drawing of the Fort Lincoln housing project (unbuilt), Washington, DC, 1966–68. Ink on paper, 29⅛ × 42⅛ in. (74 × 107 cm)

Fig. 37 Isometric drawing of Oriental Masonic Gardens (demolished), New Haven, Connecticut, 1968. Ink on paper, 36¼ × 39¾ in. (92 × 101 cm)

Fig. 40 Perspective study of the Graphic Arts Center project (unbuilt), New York, ca. 1967. Graphite on tracing paper, 33¾ × 63⅜ in. (85.7 × 161.1 cm)

Fig. 41 Model for the Graphic Arts Center project (unbuilt), New York, ca. 1967. Balsa wood and plastic, 71 × 32½ × 24½ in. (180.3 × 82.6 × 62.2 cm)

Fig. 42 Section drawing of the Graphic Arts Center project (unbuilt), New York, ca. 1967. Ink and graphite on Mylar, 35 × 64⅛ in. (89 × 163 cm)

Fig. 44 Aerial perspective view and section of the Lower Manhattan Expressway / City Corridor project (unbuilt), New York, ca. 1967. Print on Mylar, 38¼ × 48 in. (97 × 122 cm)

Fig. 45 Perspective section drawing of the Lower Manhattan Expressway / City Corridor project (unbuilt), New York, 40 × 33½ in. (101.6 × 85.1 cm). The Museum of Modern Art, New York, Gift of the Howard Gilman Foundation (1290.2000)

Fig. 46 Perspective drawing of the Lower Manhattan Expressway / City Corridor project (unbuilt), New York, 1967–72. Ink on tracing paper, 21½ × 30 in. (54.6 × 76.2 cm)

Fig. 47 Perspective drawing of the Lower Manhattan Expressway / City Corridor project (unbuilt), New York, 1967–72. Ink on tracing paper, 21½ × 30 in. (54.6 × 76.2 cm)

Fig. 49 Perspective section drawing of Rudolph's architectural office (demolished) on West 58th Street, New York, 1964. Ink on paper, 24 × 57⅞ in. (61 × 147 cm)

Fig. 56 Perspective section drawing of Rudolph's quadruplex apartment at 23 Beekman Place, New York, ca. 1976. Ink over graphite on paper, 26¾ × 35 in. (68 × 89 cm)

Fig. 59 Perspective drawing of the apartment at 23 Beekman Place, with view toward East River, ca. 1976. Ink on paper, 16¼ × 54⅛ in. (41.3 × 137.5 cm)

Fig. 61 Perspective drawing of the Modulightor Building, 246 East 58th Street, New York, ca. 1989. Ink on Mylar, 42⅛ × 19¼ in. (107 × 49 cm)

Fig. 62 Facade study model for the Modulightor Building, ca. 1989. Foam board, cardstock paper, and acrylic sheet, 17¼ × 5 × 2⅛ in. (43.7 × 12.7 × 5.3 cm)

Fig. 66 Perspective rendering of the Colonnade, Singapore, 1980. Photomechanical print, 52 × 36 in. (132.2 × 91.4 cm)

Fig. 67 Perspective drawing (early design) of the Concourse / Beach Road II Office Tower project, Singapore, 1981. Ink and graphite on tracing paper, 79½ × 39½ in. (201.9 × 100.3 cm). The Museum of Modern Art, New York, Gift of the architect in honor of Philip Johnson (393.1996)

Fig. 68 Perspective drawing of the lobby interior of the Concourse (partially demolished), Singapore, 1983. Ink and graphite on Mylar, 29½ × 40⅛ in. (75 × 102 cm)

Fig. 69 Perspective drawing of the Sino Tower / Harbour Road project (unbuilt), Hong Kong, 1989. Ink on paper, 27⅛ × 46⅛ in. (69 × 117 cm)

Fig. 70 Architectural model for the proposed Sino Tower (unbuilt), Hong Kong, 1989. Balsa wood and plastic, 48 × 34¼ × 25 in. (121.9 × 87 × 63.5 cm)

Fig. 71 Perspective drawing of the Bond Centre (now Lippo Centre), Hong Kong, ca. 1984. Graphite on tracing paper, 51⅞ × 24⅞ in. (131.7 × 63.2 cm)

Fig. 72 Perspective drawing of the International Building for Hong Fok Corporation (unbuilt), Singapore, 1990. Ink on tracing paper, 31⅞ × 33¼ in. (81 × 85.6 cm)

Fig. 73 Perspective drawing of the Wisma Dharmala Headquarters Building (now Intiland Tower), Jakarta, Indonesia, ca. 1982. Colored pencil over diazo print, 16⅛ × 20⅛ in. (41 × 51 cm)

NOTES

1 Herbert Muschamp, "Paul Rudolph Is Dead at 78; Modernist Architect of the 60's," *New York Times*, August 9, 1997, 50.

2 Muschamp, "Paul Rudolph Is Dead at 78," 50.

3 David Jacobs, "The Rudolph Style: Unpredictable," *New York Times Magazine*, March 26, 1967, 57.

4 For more on the reception of Rudolph's career, see Timothy M. Rohan, *The Architecture of Paul Rudolph* (New Haven and London: Yale University Press, 2014), 6–7; for more on the reexamination of Rudolph's legacy, see *Reassessing Rudolph*, edited by Timothy M. Rohan (New Haven: Yale School of Architecture, 2017).

5 See Timothy M. Rohan, "Reputations: Paul Rudolph (1918–1997)," *Architectural Review*, November 17, 2014, https://www.architectural -review.com/essays /reputations/paul-rudolph -1918-1997; Rohan, *Architecture of Paul Rudolph*, 14.

6 Walter Gropius, letter to Chief of Naval Personnel, November 7, 1951, quoted in Christopher Domin and Joseph King, *Paul Rudolph: The Florida Houses* (New York: Princeton Architectural Press, 2002), 32.

7 See Sigfried Giedion, "The Need for a New Monumentality," in *New Architecture and City Planning, a Symposium*, edited by Paul Zucker (New York: Philosophical Library, 1944), 549–68.

8 Paul Rudolph, "Regionalism in Architecture," *Perspecta* 4 (1957): 16.

9 Paul Rudolph, "The Six Determinants of Architectural Form," *Architectural Record* 120, no. 4 (October 1956): 183.

10 Paul Rudolph and Rupert Spade, *Paul Rudolph* (New York: Simon and Schuster, 1971), 14.

11 Stanley Tigerman, "Say No, But Get It Built," *Journal of Architectural Education* 65, no. 1 (October 2011): 64–65.

12 See Mark Pasnik, Michael Kubo, and Chris Grimley, *Heroic: Concrete Architec- ture and the New Boston* (New York: Monacelli Press, 2015).

13 Rohan, *Architecture of Paul Rudolph*, 180.

14 Susan Grey, ed., *Architects on Architects* (New York: McGraw-Hill Education, 2001), 27.

15 Paul Rudolph, *Paul Rudolph: Drawings* (Tokyo: A.D.A. EDITA Tokyo, 1972), 7–8.

16 See Timothy M. Rohan, "Drawing as Signature: Paul Rudolph and the Per- spective Section," in Rohan, *Reassessing Rudolph*, 130–33, for further discus- sion of Rudolph's drawings and the involvement of his Yale students in these renderings.

17 Reyner Banham, "Convenient Benches and Handy Hooks: Functional Considerations in the Criticism of the Art of Architecture," in *The History, Theory and Criticism of Architecture: Papers from the 1964 AIA-ACSA Teacher Seminar*, edited by Marcus Whiffen (Cambridge, MA: MIT Press, 1965), 102, quoted in Timothy M. Rohan, "Rendering the Surface: Paul Rudolph's Art and Architecture Building at Yale," *Grey Room*, no. 1 (Autumn 2000): 87. Rohan's article offers an excellent general analysis of the relationship between Rudolph's drawings and the material qualities of his buildings.

18 This late project is the David Eu Residence, Singapore, which was begun in 1994 and was one of a handful of proj- ects that Rudolph was ac- tively working on at the time of his death in 1997. See also the comprehensive list of buildings and projects by Ru- dolph in Rohan, *Architecture of Paul Rudolph*, 250–60.

19 Paul Rudolph, "3 New Direc- tions," *Perspecta* 1 (Summer 1952): 21.

20 Rudolph, "3 New Directions."

21 Pat Kirkham and Tom Tredway, "Paul Rudolph and 'New Materials': From Ply- wood to Plexiglas and More," in Rohan, *Reassessing Rudolph*, 63.

22 Rudolph, describing the engineering test for the Hook Guest House (1951–53), quoted in Sibyl Moholy-Nagy and Paul Rudolph, *The Architecture of Paul Rudolph* (New York: Praeger, 1970), 36.

23 Domin and King, *Paul Rudolph*, 30.

24 Kirkham and Tredway, "Paul Rudolph and 'New Materials,'" 66.

25 Rudolph, "3 New Directions," 25.

26 Paul Rudolph, "Rudolph and the Roof," *House and Home* 3, no. 6 (June 1953): 141, quoted in Kirkham and Tredway, "Paul Rudolph and 'New Materials,'" 66.

27 Paul Rudolph, quoted in Michael McDonough, "The Beach House in Paul Ru- dolph's Early Work," Master's thesis, School of Architec- ture, University of Virginia, 1986, quoted in Domin and King, *Paul Rudolph*, 30.

28 Paul Rudolph, quoted in Moholy-Nagy and Rudolph, *Architecture of Paul Rudolph*, 34.

29 Rohan, *Architecture of Paul Rudolph*, 28.

30 Rohan, *Architecture of Paul Rudolph*, 30.

31 "Property from the Descen- dants of Dr. Walter Willard Walker: Paul Rudolph, The Walker Guest House," Sotheby's, Important Design auction, December 12, 2019, lot 343, https:// www.sothebys.com/en/buy /auction/2019/important -design/paul-rudolph -the-walker-guest-house.

32 Paul Goldberger, "Paul Rudolph's Architectural Ideal," Sotheby's online cata- logue article for the sale of the Walker Guest House, December 12, 2019, https:// www.sothebys.com/en /articles/paul-rudolphs -florida-walker-guest-house -an-architectural-ideal.

33 Rudolph, "Regionalism in Architecture," 16.

34 Rudolph, "Regionalism in Architecture," 17.

35 Roberto De Alba, *Paul Rudolph: The Late Work* (New York: Princeton Archi- tectural Press, 2003), 44.

36 Louis Kahn, quoted in Michael Snyder, "The Un- expectedly Tropical History of Brutalism," *T: The New York Times Style Magazine*, Aug. 15, 2019, https:// www.nytimes.com/2019/08 /15/t-magazine/tropical

-brutalism.html. My discussion of the origins of the term "Brutalism" draws on Barbara A. Campagna, "Redefining Brutalism," *APT Bulletin: The Journal of Preservation Technology* 51, no. 1 (2020): 26.

37 Le Corbusier, quoted in Campagna, "Redefining Brutalism," 26.

38 Snyder, "The Unexpectedly Tropical History of Brutalism," also quoted in Campagna, "Redefining Brutalism," 26.

39 Campagna, "Redefining Brutalism," 27.

40 Campagna, "Redefining Brutalism," 26.

41 For an excellent in-depth case study of urban-renewal practices and their societal impact within Washington, DC, from the 1960s to the 1980s, see the online records relating to *A Right to the City*, an exhibition held at the Smithsonian Anacostia Community Museum, Washington, DC, April 21, 2018– October 1, 2020, https:// anacostia.si.edu/collection /archives/sova-acma-03-119.

42 Lizbeth Cohen and Brian D. Goldstein, "Paul Rudolph and the Rise and Fall of Urban Renewal," in Rohan, *Reassessing Rudolph*, 15.

43 Cohen and Goldstein, "Paul Rudolph and the Rise and Fall of Urban Renewal," 22.

44 Martin Marietta advertisement, Paul Marvin Rudolph Archive, Library of Congress, Prints and Photographs Division, Washington, DC; unprocessed in PR 13 CN 2001:126, PMR-3181-2, no. 3, https://www.loc.gov /item/2023637732/.

45 Cohen and Goldstein, "Paul Rudolph and the Rise and Fall of Urban Renewal," 22.

46 Nick Miller, "Five Paul Rudolph Buildings Under Threat in Buffalo," *The Architect's Newspaper*, November 5, 2013, cited in Campagna, "Redefining Brutalism," 27.

47 Arthur Drexler, quoted in the press release for the *Work in Progress* exhibition, Museum of Modern Art, New York, October 1, 1970, 3, https://assets.moma.org /documents/moma_press -release_326704.pdf.

48 See Paul Rudolph Institute for Modern Architecture,

project description for Stafford Harbor, https:// www.paulrudolph.institute /196602-stafford-harbor.

49 "Architect Rudolph and His Town-to-Be," *New York Times Magazine*, March 26, 1967.

50 Rudolph, quoted in Nan R. Piene, "Paul Rudolph Designs a Town," *Art in America* 55 (July/August 1967): 59.

51 Robert A. M. Stern, Thomas Mellins, and David Fishman, *New York 1960: Architecture and Urbanism between the Second World War and the Bicentennial* (New York: Monacelli Press, 1997), 945.

52 Moholy-Nagy and Rudolph, *Architecture of Paul Rudolph*, 220.

53 Moholy-Nagy and Rudolph, *Architecture of Paul Rudolph*, 220.

54 Fred Bernstein, "A Road Trip Back to the Future," *New York Times*, March 23, 2007, 10.

55 Rudolph, quoted in John W. Cook and Heinrich Klotz, *Conversations with Architects: Philip Johnson, Kevin Roche, Paul Rudolph, Bertrand Goldberg, Morris Lapidus, Louis Kahn, Charles Moore, Robert Venturi & Denise Scott Brown* (New York: Praeger Publishers, 1973), 120.

56 Bernstein, "A Road Trip Back to the Future," 10.

57 McGraw-Hill Publications advertisement, Paul Marvin Rudolph Archive, Library of Congress, Prints and Photographs Division, Washington, DC; unprocessed in PR 13 CN 2001:126, PMR-3026-2, no. 3, https://www.loc.gov /item/2023637723/.

58 McGraw-Hill Publications advertisement.

59 Moholy-Nagy and Rudolph, *Architecture of Paul Rudolph*, 9.

60 Joseph Esherick, from an interview with Michael J. Crosbie, *Architecture* (November 1988): 102–7, quoted in John Morris Dixon, *Paul Rudolph: Inspiration and Process in Architecture* (New York: Princeton Architectural Press, 2020), 13.

61 Rudolph, quoted in John Zinsser, "Staying Creative; Artistic Passion Is a Lifelong Pursuit—and These Mature

Masters Prove the Point (Otto Luening, Elizabeth Catlett, Paul Rudolph)," *50 Plus 25* (December 1985): 55.

62 Freya Wigzell, "The People Here Think I'm Out of My Mind," *AA Files*, no. 75 (2017): 14.

63 Charles Jencks, "Esprit Nouveau est mort à New Haven, or Meaningless Architecture," *Connection: Visual Arts at Harvard*, January 28, 1964, 20.

64 Jacobs, "The Rudolph Style: Unpredictable," 47.

65 Ellen Perry Berkely, "Yale: A Building as a Teacher," *Architectural Forum* 127, no. 1 (July/August 1967): 50, cited in Tom McDonough, "The Surface as Stake: A Postscript to Timothy M. Rohan's 'Rendering the Surface,'" *Grey Room*, no. 5 (Autumn 2001): 104–5.

66 Rohan, "Rendering the Surface," 85.

67 Robert Venturi, Steven Izenour, and Denise Scott Brown, *Learning from Las Vegas* (Rev. ed., Cambridge, MA: MIT Press, 1972), 90–103.

68 For an in-depth study of the relationship between Rudolph and Logue, see Cohen and Goldstein, "Paul Rudolph and the Rise and Fall of Urban Renewal," in Rohan, *Reassessing Rudolph*, 15–27.

69 Moholy-Nagy and Rudolph, *Architecture of Paul Rudolph*, 14.

70 Paul Rudolph, "The DNA of Architecture," lecture given at the Southern California Institute of Architecture, Los Angeles, September 2, 1995, https://www.youtube.com /watch?v=yB2caWQwY9Y.

71 Moholy-Nagy and Rudolph, *Architecture of Paul Rudolph*, 18.

72 Timothy M. Rohan, "Scenographic Urbanism: Paul Rudolph and the Public Realm," *Places Journal* (June 2014), https://doi.org/10.22269 /140623.

73 Moholy-Nagy and Rudolph, *Architecture of Paul Rudolph*, 94.

74 Rudolph, quoted in Carl John Black, "A Vision of Human Space," *Architectural Record* 154, no. 1 (July 1973): 105–16.

75 Rohan, "Scenographic Urbanism."

76 Moholy-Nagy and Rudolph, *Architecture of Paul Rudolph*, 152.

77 Rohan, "Scenographic Urbanism."

78 Rohan, "Scenographic Urbanism."

79 Mildred Schmertz, "A Chapel for Tuskegee by Rudolph," *Architectural Record* 146, no. 5 (November 1969): 117.

80 Karla Cavarra Britton and Daniel Ledford, "Paul Rudolph and the Psychology of Space," *Journal of the Society of Architectural Historians* 78, no. 3 (September 2019): 335.

81 Rudolph, quoted in Zinsser, "Staying Creative," 49.

82 Ada Louise Huxtable, "Creations of 3 Top Architects Shown," *New York Times*, September 30, 1970, 38, quoted in Rohan, *Architecture of Paul Rudolph*, 178.

83 See "Twentieth Century Bricks," *Architectural Forum* 136, no. 5 (June 1972): 48.

84 Examples include Container City (2001–2) in London and the Wenckehof container-tower housing complex in Amsterdam.

85 Rohan, *Architecture of Paul Rudolph*, 151.

86 Harold B. Finger, Assistant Secretary for Research and Technology, Department of Housing and Urban Development, "Operation Breakthrough: A Nationwide Effort to Produce Millions of Homes," *HUD Challenge* (November/December 1969): 6, https://www.huduser.gov/portal/portal/sites/default/files/pdf/HUD-Challenge-November-December-1969.pdf.

87 George Romney, "Foreword," *Operation Breakthrough: Mass Produced and Industrialized Housing: A Bibliography* (Washington, DC: Department of Housing and Urban Development, 1970), ii.

88 Ian Ball, "Storey with an Unhappy Ending," *Daily Telegraph Magazine*, December 13, 1968, 30.

89 Rudolph, quoted in Ball, "Storey with an Unhappy Ending," 30.

90 Rohan, *Architecture of Paul Rudolph*, 160.

91 Rudolph, quoted in Ball, "Storey with an Unhappy Ending," 30.

92 Paul Goldberger, "Paul Rudolph's Manhattan Mega-structure," *The New Yorker*, November 8, 2010, https://www.newyorker.com/news/news-desk/paul-rudolphs-manhattan-megastructure.

93 Moholy-Nagy and Rudolph, *Architecture of Paul Rudolph*, 18.

94 Rudolph, quoted in Cook and Klotz, *Conversations with Architects*, 105.

95 See Rohan, "Scenographic Urbanism."

96 Paul Rudolph, "The Changing Face of New York," *American Institute of Architects Journal* 131 (April 1959): 39.

97 George Nelson, ed., *Display*, Interiors Library series, 3 (New York: Whitney Publications, 1953), 134.

98 Sylvia Lavin, *Kissing Architecture* (Princeton, NJ: Princeton University Press, 2011), 62.

99 C. Ray Smith, "Rudolph's Dare-Devil Office Destroyed," *Progressive Architecture* 50 (April 1969): 98.

100 Moholy-Nagy and Rudolph, *Architecture of Paul Rudolph*, 80.

101 Paul Goldberger, "Halston's Hideaway," *New York Times Magazine*, July 24, 1977, 35.

102 "Total Townhouse," *House and Garden* 136, no. 5 (November 1969): 125.

103 Kirkham and Tredway, "Paul Rudolph and 'New Materials,'" 70.

104 "Total Townhouse," 126.

105 Halston, quoted in Goldberger, "Halston's Hideaway," 35.

106 Rudolph, quoted in "A Spectacular Apartment by Paul Rudolph," *House and Garden* 148, no. 10 (October 1976): 116.

107 Joseph Giovannini, "If There's Heaven, It Should Expect Changes," *New York Times*, August 14, 1997, C1.

108 Rohan, *Architecture of Paul Rudolph*, 209.

109 Rohan, *Architecture of Paul Rudolph*, 209.

110 "A Spectacular Apartment by Paul Rudolph," 118.

111 Kirkham and Tredway, "Paul Rudolph and 'New Materials,'" 72.

112 Michael Sorkin, "The Light House," *House and Garden* 160, no. 1 (January 1988): 89. On November 16, 2010, the New York City Landmarks Preservation Commission designated the exterior of 23 Beekman Place; see https://www.nyclgbtsites.org/wp-content/uploads/2021/06/Paul-Rudolph-Penthouse-and-Apartments-Designation-Report.pdf.

113 "Water: From Its Swirling Source, Water Inspires Architect Paul Rudolph to Design Two Exciting and Prophetic Baths," *House and Garden* 148, no. 2 (February 1976): unpag.

114 Rudolph was featured prominently in Joan Kron and Suzanne Slesin, *High-Tech: The Industrial Style and Source Book for the Home* (New York: Clarkson Potter, 1978), which was widely referenced by interior designers in the 1980s.

115 Paul Rudolph, "Enigmas of Architecture," *A+U Architecture and Urbanism* (1977): 317–20.

116 Billy Cheng, "Walking the Bridge: Paul Rudolph's Urban Connections," *M+ Magazine*, December 28, 2023, https://www.mplus.org.hk/en/magazine/walking-the-bridge-rudolphs-urban-connections/.

117 Rudolph had repeatedly expressed this desire to his partner, Ernst Wagner; see Rohan, *Architecture of Paul Rudolph*, 223.

118 For example, *From Concept to Building: A Project in Singapore by Architect Paul Rudolph*, Cooper Hewitt, Smithsonian Design Museum, New York, November 9, 1993–February 20, 1994; *Paul Rudolph: Four Recent Projects in Southeast Asia*, Graham Foundation, Chicago, May 6–28, 1987.

119 Kurt Forster, "A Brief Memoir of the Long Life and Short Fame of Paul Rudolph," *ANY: Architecture New York*, no. 21 (1997): 15.

120 Michael Sorkin, "The Invisible Man," in *Exquisite Corpse: Writing on Buildings* (London: Verso, 1994), 155.

121 Sylvia Lavin, "Unhabituated Architecture," in Rohan, *Reassessing Rudolph*, 110.

122 Muschamp, "Paul Rudolph Is Dead at 78," 50.

SELECTED BIBLIOGRAPHY

Bell, Eugenia, ed. *Paul Rudolph: Inspiration and Process in Architecture*. Hudson, NY: Princeton Architectural Press, 2020.

Bruegmann, Robert, et al. *Paul Rudolph: Dreams and Details*. New York: Steelcase Design Partnership, 1989.

Bussard, Katherine A., Alison Fisher, and Greg Foster-Rice. *The City Lost and Found: Capturing New York, Chicago, and Los Angeles, 1960–1980*. Exh. cat. Princeton: Princeton University Art Museum, 2014.

Cook, John Wesley, and Heinrich Klotz. *Conversations with Architects: Philip Johnson, Kevin Roche, Paul Rudolph, Bertrand Goldberg, Morris Lapidus, Louis Kahn, Charles Moore, Robert Venturi and Denise Scott Brown*. New York: Praeger, 1973.

De Alba, Roberto. *Paul Rudolph: The Late Work*. New York: Princeton Architectural Press, 2003.

Domin, Christopher, and Joseph King. *Paul Rudolph: The Florida Houses*. New York: Princeton Architectural Press, 2002.

Franzen, Ulrich, Paul Rudolph, and Peter M. Wolf. *The Evolving City: Urban Design Proposals*. New York: Whitney Library of Design, 1974.

Goldhagen, Sarah Williams, and Réjean Legault. *Anxious Modernisms: Experimentation in Postwar Architectural Culture*. Montreal: Canadian Centre for Architecture; Cambridge, MA: MIT Press, 2000.

Kilian, Steven, Ed Rawlings, and Jim Walrod. *Paul Rudolph: Lower Manhattan Expressway*. Exh. cat. New York: Drawing Center, 2010.

Lending, Mari. *Plaster Monuments: Architecture and the Power of Reproduction*. Princeton: Princeton University Press, 2017.

Leung, Nora. *Experiencing Bond Centre*. Hong Kong: Studio Publications, 1990.

Monk, Tony. *The Art and Architecture of Paul Rudolph*. New York: Wiley and Sons, 1999.

Mottalini, Chris, and Allison Arieff. *After You Left / They Took It Apart: Demolished Paul Rudolph Homes*. Chicago: Columbia College Chicago Press, 2013.

Nelson, George. *Display*. New York: Whitney Publications, 1953.

Pasnik, Mark, Michael Kubo, and Chris Grimley. *Heroic: Concrete Architecture and the New Boston*. New York: Monacelli Press, 2015.

Pelkonen, Eeva-Liisa. *Untimely Moderns: How Twentieth-Century Architecture Reimagined the Past*. New Haven: Yale University Press, 2023.

Rohan, Timothy M. *The Architecture of Paul Rudolph*. New Haven: Yale University Press, 2014.

———. *Model City: Buildings and Projects by Paul Rudolph for Yale and New Haven: November 3, 2008–February 6, 2009*. Exh. cat. New Haven: Yale School of Architecture, 2008.

———, ed. *Reassessing Rudolph*. New Haven: Yale School of Architecture, 2017.

Rudolph, Paul. *Paul Rudolph: Drawings*. Tokyo: A.D.A. EDITA Tokyo, 1972.

———. *Paul Rudolph Retrospective Exhibition 1967*. Exh. cat. Tampa: Tampa Bay Art Center, University of Tampa, 1967.

———. *Paul Rudolph: The Hong Kong Journey*. New York: Paul Rudolph Heritage Foundation, 2018.

———. *Paul Rudolph: The Personal Laboratory*. New York: Paul Rudolph Heritage Foundation, 2019.

———. *Writings on Architecture*. New Haven: Yale University Press, 2009.

Rudolph, Paul, and Sibyl Moholy-Nagy. *The Architecture of Paul Rudolph*. New York: Praeger, 1970.

Rudolph, Paul, and Toshio Nakamura. *100 Works by Paul Rudolph, 1946–74*. Tokyo: A and U Publishing, 1977.

Rudolph, Paul, and Rupert Spade. *Paul Rudolph*. New York: Simon and Schuster, 1971.

Smith, C. Ray. *Supermannerism: New Attitudes in Post-Modern Architecture*. New York: Dutton, 1977.

Sorkin, Michael. *Exquisite Corpse: Writing on Buildings*. London: Verso, 1991.

Stern, Robert A. M. *Architecture on the Edge of Postmodernism: Collected Essays, 1964–1988*. New Haven: Yale University Press, 2009.

Stern, Robert A. M., and Jimmy Stamp. *Pedagogy and Place: 100 Years of Architecture Education at Yale*. New Haven: Yale University Press, 2016.

Venturi, Robert, Denise Scott Brown, and Steven Izenour. *Learning from Las Vegas: The Forgotten Symbolism of Architectural Form*. Rev. ed. Cambridge, MA: MIT Press, 1978.

Wolf, Peter M. *The Future of the City: New Directions in Urban Planning*. New York: Whitney Library of Design, 1974.

Yale University School of Architecture. *Paul Rudolph: Drawings for the Art and Architecture Building at Yale, 1959–1963*. New Haven: Yale University School of Architecture, 1988.

INDEX

Page numbers in italics refer to illustrations.

PHOTOGRAPH CREDITS

This catalogue is published in conjunction with *Materialized Space: The Architecture of Paul Rudolph*, on view at The Metropolitan Museum of Art, New York, from September 30, 2024, through March 16, 2025.

The exhibition was organized by The Metropolitan Museum of Art in collaboration with the Library of Congress's Paul Marvin Rudolph Archive.

The exhibition is made possible by The Modern Circle.

Additional support is provided by The Daniel and Estrellita Brodsky Foundation, and Ann M. Spruill and Daniel H. Cantwell.

This publication is made possible by the Samuel I. Newhouse Foundation, Inc.

Published by The Metropolitan Museum of Art, New York
Mark Polizzotti, Publisher and Editor in Chief
Peter Antony, Associate Publisher for Production
Michael Sittenfeld, Associate Publisher for Editorial

Edited by Elisa Urbanelli
Production by Lauren Knighton
Designed by Michael Dyer, Remake
Image acquisitions and permissions by Jenn Sherman

Photography credits appear on page 127.

Typeset in Gerstner Programm
Printed on Magno Volume 170 gsm
Separations by Verona Libri, Verona, Italy
Printed and bound by Verona Libri, Verona, Italy

FSC
www.fsc.org
MIX
Paper | Supporting responsible forestry
FSC® C119614

Cover: front, Tuskegee Institute Chapel (now Tuskegee University), Tuskegee, Alabama, ca. 1960 (fig. 32, detail); back, Lower Manhattan Expressway / City Corridor project (unbuilt), 1967–72 (fig. 47, detail); interior, Fort Lincoln housing project (unbuilt), 1966–68 (fig. 35, detail)

Page 1: Colonnade apartment building, Singapore, 1980 (fig. 66, detail); pages 20–21: Knott Residence (unbuilt), Yankeetown, Florida, ca. 1951 (fig. 6, detail); pages 32–33: Tracey Towers housing project, Bronx, New York, 1967 (fig. 17, detail); pages 42–43: Burroughs-Wellcome Company Headquarters (demolished), North Carolina, 1969–72 (fig. 28, detail); pages 62–63: Lower Manhattan Expressway / City Corridor project (unbuilt), 1967–72 (fig. 46, detail); pages 82–83: Rudolph's architectural office on West 58th Street, New York (fig. 49, detail); pages 102–3: Concourse / Beach Road II Office Tower project, Singapore, 1983 (fig. 68, detail); pages 116–17: Married Student Housing at Yale University, New Haven, Connecticut, ca. 1960 (fig. 5, detail)

The Metropolitan Museum of Art
1000 Fifth Avenue
New York, New York 10028
metmuseum.org

Distributed by
Yale University Press, New Haven and London
yalebooks.com/art
yalebooks.co.uk

Cataloguing-in-Publication Data is available from the Library of Congress.
ISBN 978-1-58839-783-6